John Hedgecoe's **Photographer's** Workbook

Simon & Schuster

John Hedgecoe's Photographer's Workbook

This book is an expanded version of John Hedgecoe's Pocket Guide to Practical Photography, edited and designed by Mitchell Beazley International Ltd., Artists House, 14-15 Manette Street, London W1V 5LB Copyright © 1979 and 1985 by Mitchell Beazley Publishers and John Hedgecoe All rights reserved including the right of reproduction in whole or in part in any form Published by Simon and Schuster A Division of Simon & Schuster, Inc. Simon and Schuster Building Rockefeller Center 1230 Avenue of the Americas New York, New York 10020 SIMON AND SCHUSTER and colophon are registered trademarks of Simon & Schuster, Inc.

Printed and bound by New Inter Litho, Milan, Italy

12345678910

Library of Congress Cataloging in Publication Data

ISBN: 0-671-50806-7

Editor Susannah Read Art Editor Mel Petersen Technical Editor Allan Shriver, Amateur Photographer Assistant Editor Jonathan Hilton Artist Harry Chow Production Julian Deeming

Contents

Equipment/Choosing a camera Cameras Lenses Black and white filters Light meters Lighting equipment Accessories The studio / Design and equipment Storage and care Film/Black and white film Color film Color variables Using the camera Focusing the aperture Exposing/Black and white Color	Page 5 6 11 16 18 20 22 24 26 28 30 32 34 36 38 40
Principles of selection Composing Background, middle distance and foreground Shape, pattern, texture and form Step-by-step photography Time of day Weather Strong natural light Color filters Mixing light Available light	42 44 48 50 52 54 56 58 60 62
Photographing the subject Still life Food Studio portraits Portraits out of doors Portrait variations Character portraits Nudes Children Groups and events Travel Vacations Seaside	64 68 70 72 74 76 78 80 82 84 86 88

Contents (continued)

Nature and landscape Water and underwater Animals in the wild Pets and zoo animals Studio techniques Interiors Architecture	90 92 94 96 98 102 104
The darkroom/Layout and equipment Developing black and white film Making black and white contact prints Making enlargements and print control Developing color film Making color prints	108 110 112 114 116 118
Tables and chartsFilm typesBlack and white negative filmsColor negative filmsInstant picture filmsColor slide filmBlack and white reversal filmCommon color kits for home	120 120 121 121 122 122
processing Chemical functions Filters for color photography Contrast filters for black and white film Filters for color or black and white film Filters for special effects Color temperature (Kelvin)	123 123 124 125 125 126
and filtration Flashgun guide number	127 127
Common errors	129
Exposure guides /daylight exposure guide Night exposure guide	136 137
Glossary	138
Index	150
Notes/Keeping notes	153

Equipment/Choosing a camera

Camera designs today offer a wide variety of picture sizes, viewfinders and body shapes and styles. Before you buy a camera find out which type is best suited to your requirements and what its capabilities are (see pp. 6-10).

A camera can be categorized by the size of negative it takes, the film type or size, or its viewing method. All cameras can be divided into two main groups—reflex and non-reflex; this refers to the viewing system. A reflex camera provides the photographer with an image of the subject as seen on a ground-glass viewing/focusing screen reflected by either a fixed mirror, in the case of the twin lens reflex (TLR), or a flip-up mirror, in the case of the single lens reflex (SLR). Also in this group are the roll-film cameras, which take either 120 or 220 film for larger negatives. Format sizes are $6 \times 4.5 \text{ cm} (2\frac{1}{4} \times 1\frac{3}{4} \text{ in})$, $6 \times 6 \text{ cm} (2\frac{1}{4} \times 2\frac{1}{4} \text{ in})$ and $6 \times 7 \text{ cm} (2\frac{1}{4} \times 2\frac{3}{4} \text{ in})$. Some of the SLRs have optional attachments for alternative format sizes.

Non-reflex cameras have direct-vision viewfinders and include the following formats: sub-miniature, 110, 126, 35 mm and halfframe 35 mm (these names refer to the film size they take).

In addition there are the view cameras (also called technical or studio cameras and used mainly by professionals) and several models of instant-picture cameras.

35 mm SLRs These may be manually operated or automatic; they have a wide variety of accessories and an enormous selection of lenses. With a manual model both aperture and shutter speed must be adjusted for

the correct exposure. An automatic is either shutter-priority or aperture-priority: with the former you set the required shutter speed and the camera selects the correct aperture; with the latter you set the required aperture and the camera selects the correct shutter speed. There are two models that will work in both ways and also have a full manual override control.

35 mm non-reflexes These have the advantage of a reasonable negative size, but the disadvantage of not accepting interchangeable lenses; however, screw-in close-up (or supplementary) lenses may be used for close-ups. They suffer from parallax error (see p. 6). Many of these cameras have automatic exposure systems.

110 and disc Compact and inexpensive, these cameras are ideal for informal photography where a larger camera might be an encumbrance. Their main disadvantage is the small negative size, which limits quality.

Large-format reflexes The TLR has been the workhorse of photography for many years. Lens interchangeability used to be non-existent or very restricted and there was the problem of parallax error. The technical advance went towards SLR roll-film cameras having negative sizes of 6 x 4.5 cm $(2\frac{1}{4} \times 1\frac{3}{4} \text{ in})$ for 15 shots on 120 film). 6 x 6 cm $(2\frac{1}{4} \times 2\frac{1}{4} \text{ in})$ (for shots on 120 film) and 6 x 7 cm $(2\frac{1}{4} \times 2\frac{3}{4} \text{ in})$ (for

10 shots on 120 film). These take interchangeable lenses, but most have leaf shutters in them (35 mm SLRs need only the one focal plane shutter in the camera body).

Instant-picture cameras Instant-picture cameras give you a fully developed single print immediately. Their disadvantages are their bulky size (though they are not heavy) and lack of negatives. Accessories are

usually limited.

Single lens reflex

With the SLR the image is viewed through the lens (TTL). Depressing the shutter release button first causes a hinged mirror to swing upwards clear of the light path before the shutter opens, and the film records the image exactly as it appeared in the viewfinder. SLR cameras using 35 mm film are most popular for general, good-quality photography. Large-format SLR cameras having a nominal negative size of 6 x 4.5 cm $(2\frac{1}{4} \times 1\frac{3}{4} \text{ in})$, 6 x 6 cm $(2\frac{1}{4} \times 2\frac{1}{4} \text{ in})$ or 6 x 7 cm $(2\frac{1}{4} \times 2\frac{3}{4} \text{ in})$ —for 15, 12 and 10 exposures respectively on 120 film—are used mostly by professionals. Many have optional prism-finder attachments, with built-in exposure meters.

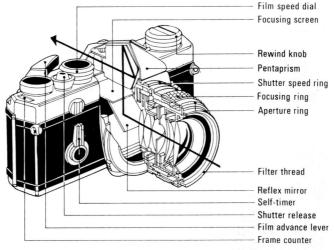

Focal plane shutters are fitted to 35 mm SLR and a few rangefinder cameras directly in front of the film plane. Most types consist of two cloth curtains (or blinds) each with a rectangular "window" arranged so that a narrow slit (the width of which is determined by a chosen shutter speed) can be drawn across the focal plane in front of the film to give the desired exposure time. Most SLRs have a maximum 1/1000 sec. shutter speed, though the usual X-sync speed is only 1/60 sec. maximum. Large-format SLRs mostly use between-lens shutters and have interchangeable lenses. Many have optional pentaprism viewfinder attachments.

Twin lens reflex

A TLR is identifiable by its two lenses: the viewing lens, through which the image of a subject being photographed is viewed (reversed left to right), focused and composed, and the taking lens, which forms an image on the film virtually identical to that formed by the viewing lens on the focusing screen. TLR cameras are bulky and unsuitable for interchangeable lenses of extreme focal lengths, but their large format, 6 cm $(2\frac{1}{4}in)$ square, means that negatives can be greatly enlarged before quality begins to be reduced.

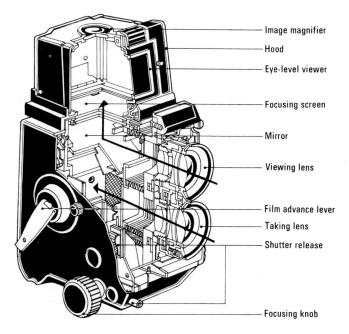

The "'leaf" or between-lens shutter is used on TLRs. Located between the elements of the taking lens, together with the diaphragm, which controls aperture, it opens from the center of the lens outward. Any speed may be used with electronic flash.

♥ Close-up subjects need careful framing, as the viewing lens ''sees'' more of the top of a subject than the taking lens. This is parallax error; compensate after viewing by raising the camera by the distance between the two lenses.

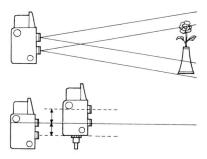

Rangefinder

Rangefinder, or non-reflex, cameras are so called because they have a rangefinder incorporated in the viewfinder; this assesses the distance between the subject and the camera's lens for accurate focus. The photographer sees a double image when the lens setting produces an image that is out of focus and a single image when the subject is correctly focused. Traditional rangefinder-type cameras are gradually being superseded by autofocus cameras. Generally, these use a similar optical system to their manually focused counterparts, but incorporate an electronic sensor that "decides" when the picture is sharp.

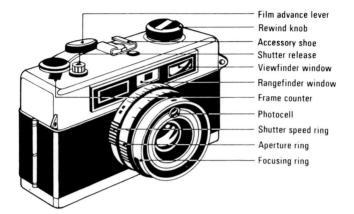

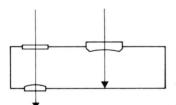

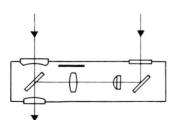

◄ Direct vision viewfinders provide an elementary ''aiming'' device ; simple lenses show the subject approximately as it is seen by the lens. They often include a bright line frame indicating the picture area, though there may only be corner markings. You will sometimes find additional marks ; these frame a smaller area and help you to correct parallax error, which is intensified when shooting close-up subjects.

The advanced rangefinder system measures the accurate focusing distance by comparing two images seen by two viewing lenses, much as a human being's two eyes estimate the distance of an object from the body. For a subject at a given distance, the separate images seen through two viewing lenses appear as one image in the viewfinder only when the pivoted mirror that is behind one lens is at the correct alignment with the image from the primary viewing lens. This alignment is controlled by the lens's focusing ring. In the viewfinder the photographer sees either two faint images. which must be adjusted to produce one strong image, or one image of the subject, which is split in the middle; the two halves must be joined to get a correctly focused subject.

Instant-picture camera

Instant-picture cameras provide the photographer with a fully developed print 30 seconds (black and white) to 8 minutes (color) after the exposure, depending on film type. There are two main film types peel-apart and dry-process films. Most cameras have automatic exposure control with a slight lighten/darken adjustment possible. Some accessories are available, but choice is very limited. Film tends to be expensive. The advantage is being able to see a print straight away; the disadvantage is that once the picture is taken, you can get a second identical print only by specially copying the first. The exception is Polaroid film Type 665, which yields a black and white print and a reusable negative. Most have direct vision viewfinders and some have fixed-focus lenses. All have leaf-type shutters.

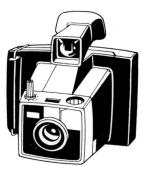

Polaroid market a variety of instant-picture cameras ranging from the simplest, above, to folding reflex models, which offer TTL viewing. These are heavier though more compact (when folded) than other instant-picture cameras.

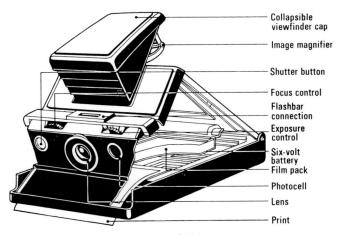

♥ 110 pocket cameras are simple, compact and cheap. Most have a fixedfocus lens and automatic exposure control; many have built-in electronic flash. They use drop-in-cartridges with a negative size of 13 x 17 mm. ♥ Sub-miniature cameras Built with great precision, they use cassette film with a negative size of about 8 x 11 mm (it varies with different models). The maximum acceptable enlargement is postcard size.

View camera

View cameras are simple in design, yet extremely versatile. They use sheet film measuring typically $10.2 \times 12.7 \text{ cm}$ (4 x 5 in), which is suitable for large-scale, specialist photography such as landscapes and architecture. The monorail type shown here (the most common design today) must be mounted on a tripod during use.

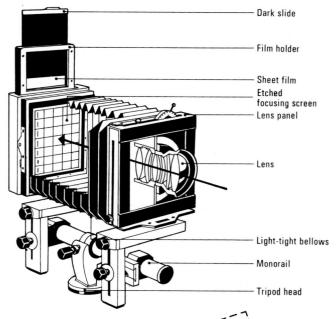

► View cameras can be adjusted while the image is viewed on the focusing screen. They have a variety of adjustments besides the usual ones for focus, aperture and (leaf) shutter speed, but they are not usually all found on a single camera. The back and front may each be made to rise, fall, slide, tilt, swing and revolve either separately or in various combinations to achieve the desired view of the subject. All these movements are with respect to the lens and film axes. After final adjustments, the focusing screen is replaced by the film holder. The film may be of the instant-picture type, or it may be in sheets or rolls.

Tilting the entire camera

upwards will bring the whole of tall structures into the lens's view, but vertical lines will appear to converge. Correct perspective is achieved by keeping the camera level with the ground (film plane perpendicular to the ground) and raising the lens panel.

Lenses

Most cameras employ complex lenses, so light of different wavelength (and hence different color) entering any part of the lens can be brought into focus at the film plane. An iris diaphragm built into the lens allows the aperture to be varied (settings are called f stops). A common range for a standard lens is between f2.8 (widest) and f16 (smallest). Apertures are varied to control exposure and depth of field (the area of sharpness around the point of true focus).

Lenses come in a variety of focal lengths. For a 35 mm format camera a 50 mm lens is standard, but for a $6 \times 6 \text{ cm} (2\frac{1}{4} \times 2\frac{1}{4} \text{ in})$ format an 80 mm lens is needed to fill the larger negative area with the same image. For the 35 mm format, a 135 mm telephoto lens gives a bigger image of a distant scene than a 28 mm wide-angle; a wide-angle has a greater field of view (74° as opposed to only 18°).

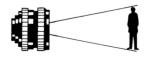

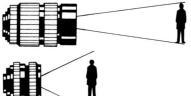

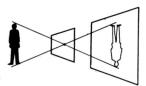

A pin-hole camera need only consist of a box with a hole to admit image-forming light and a negative to register the image.

A simple lens may have only one element, which focuses most rays of light into a coherent image at the film (image) plane.

A compound lens may have up to seven elements (individual lenses). Two or more cemented together form a group. Each element and group of elements is designed to correct a particular lens aberration.

- Front element
- Two-element group
- Air-to-glass surface
 - Iris diaphragm blades

- Lens barrel

A normal (or standard)

lens gives an image size that approximates the view as seen by the human eye. Most fixed-lens cameras have a standard lens.

S A telephoto lens has a narrow angle of view (sometimes only 2°), but produces an image large enough to fill the negative so the subject appears larger

A wide-angle lens fills the negative with up to 180° of the scene by reducing subject size. This is an advantage when shooting large groups or in a restricted area.

Lenses

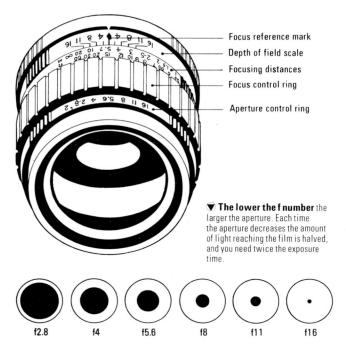

The controls you find on most lens barrels are the aperture control ring and the focus control ring. On rangefinder cameras the shutter speed control ring is found just behind the lens; where it joins the camera body. Other information to be found on lenses is a depth of field scale, in both feet and meters, and an infra-red focusing mark. Apertures are aligned against a fixed reference mark and the focusing ring should be turned until the viewfinder shows a sharp image.

Changing aperture affects both exposure and depth of field. The smaller the aperture the greater the depth of field ; more of the area behind and in front of the subject will be rendered acceptably sharp. The effect of opening up one stop (f11 instead of f16) doubles the amount of light entering the lens and, to maintain correct exposure, the exposure time needs to be halved (1/125 instead of 1/60).

Changing focal length affects not only image size but also depth of field. A 135 mm telephoto lens gives a greater image size than does a 28 mm wide-angle lens, but the depth of field associated with a lens at a given aperture and focusing distance is also affected by focal length. Assuming a consistent aperture and focusing distance, the shorter the focal length the greater the depth of field.

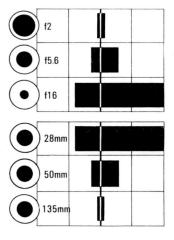

The greater a lens's focal length the less its angle of view. As the focal length increases the minimum focusing distance also increases. The minimum focusing distance for a 50 mm lens may be 0.45 m ($\frac{1}{2}$ yd), but the closest object a 250 mm telephoto lens can focus on may be as distant as 6 m ($\frac{61}{2}$ yd).

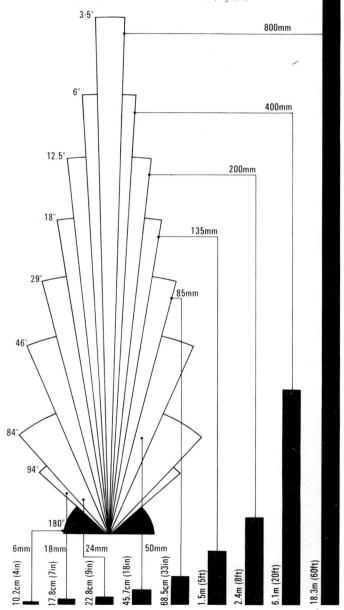

13

Lenses

15 mm Ultra wide-angle for interiors—it embraces a wide view without undue distortion and for landscapes it can take in the immediate foreground and the sky almost directly overhead.

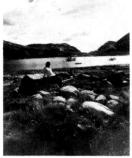

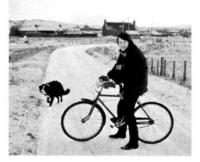

28 mm The wide-angle I prefer. It has an extensive depth of field and produces virtually no distortion. Notice how images diminish or increase according to the lens you use.

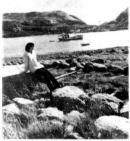

50 mm Closest to human eyesight, this lens gives a ''normal'' relationship between different image planes. It has the fastest apertures and is the ideal general-purpose lens.

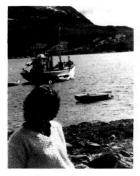

135 mm The longest easily hand-held lens; ideal for portraiture. It pulls the background up sharply, enabling you to get close-ups of difficult subjects from a reasonable distance.

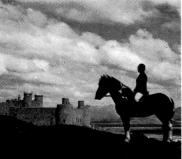

200 mm Excellent for close-ups and useful for relating middle-distance subjects and background. If you want to hand hold you must shoot at 1/250 or more. f4 is usually the widest aperture available.

Tele-converter This enables you to extend the focal length; a 2x converter turns a 200 mm into a 400 mm, as above. There is a slight loss in definition, but results are acceptable.

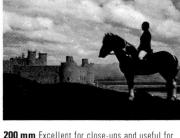

Black and white filters

Filters are simply pieces of colored transparent material (usually glass) that screw into the threaded mount on the front of your lens. They work on the principle of allowing some light components to pass through the filter and reach the film while blocking others. For example, a blue filter will let blue light pass through and block yellow, orange and red. In this way shades of gray produced by a black and white film can be manipulated either to resemble the tonal strengths of a scene as viewed by the eye more closely, or to emphasize parts of a scene that would normally pass unnoticed because of the film's inability to reproduce all colors as different shades of gray.

You do not need a large range of filters for black and white photography. Limit yourself to only two or three to start with a yellow filter to darken skies slightly and make foliage appear lighter; an orange filter to accentuate the contrast between sky and cloud and bring out the texture of such surfaces as brick and wood, and a UV or haze filter, which is a general-purpose filter used for eliminating the worst effects of ultraviolet light, pronounced in distant scenes or near large expanses of water. (For further details see p. 125.)

Care of filters is vital. Before attaching a filter make sure it is free from dust and fingerprints. If dirty, clean with a soft, lintfree cloth or lens tissue. Greasy or scratched filters will seriously degrade the images produced by the finest optics. Lens-cleaning fluid can also be used to remove particularly stubborn marks. Always replace the filter in its case when it is not in use.

Each photograph on the page opposite was taken using a different filter. The pictures were shot in HP5 using a Pentax with 35 mm lens. Exposure was varied each time to compensate for the light-blocking strength of each filter. (For details on filter factors, see table on p. 125.)

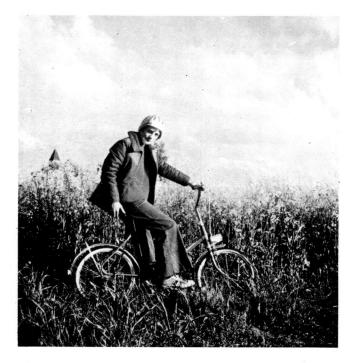

A yellow filter was used, right, to lighten the foreground and middle-distance vegetation. This is a useful filter to have if you plan to do a certain amount of landscape photography as it also has the effect of increasing the contrast between cloud and sky slightly.

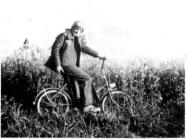

The green filter right, has darkened the boy's jumper quite considerably. His trousers, which are blue, now appear slightly darker and tonal contrast in the sky has become slightly stronger.

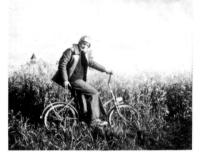

Using a blue filter has noticeably altered the atmosphere of the photograph, right. Instead of a bright sunny day the weather now appears very misty. Contrast between sky and cloud has completely disappeared and the cyclist's trousers now seem almost white. Shadow detail has also decreased.

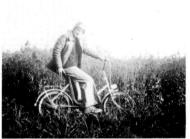

► A red filter produces the most pronounced sky effects. The clouds in this shot are now clearly distinguishable from the background sky. The blue of the cyclist's trousers now appears darker than in the unfiltered shot and his jumper is now white. This filter needed the greatest exposure allowance—three stops.

Light meters

If your camera does not have a built-in light meter and you find it difficult judging exposures by using the recommended camera settings accompanying the film pack, the best way to guarantee accurate exposure is to use a hand-held meter. These meters give you a range of alternative shutter speeds and aperture settings, and are preferred by many professionals.

The selenium cell exposure meter

needs no outside power source. When exposed to light the cell generates an electrical current in direct proportion to the amount of light falling upon it. This, in turn, activates a needle, which moves across a calibrated scale indicating various shutter speeds and aperture combinations. In bright light the selenium cell is as accurate as most other light meters, but in low light conditions a flap that normally covers the cell must be removed.

▶ CdS (cadmium sulphide) cell exposure meters have a wide sensitivity range and are reliable in low light, but they do tend to 'remember' a high light reading for a short time after exposure. The CdS meter, although very similar in appearance to the selenium cell meter, needs a small battery to activate it. The cell becomes a resistor, restricting an electrical current in proportion to the light reaching it.

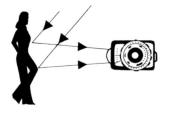

A reflected light reading is adequate for most situations—especially landscapes and medium-toned subjects. The light meter cell is pointed at the subject and measures the light reflected back. All TTL meters work on this principle.

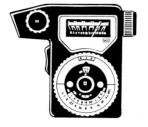

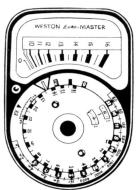

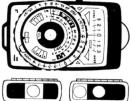

An incident light reading is a measure of the light falling on the subject. A diffuser cone, to enlarge the angle of acceptance of the light-sensitive cell, is placed over the cell, which is then pointed back toward the light source.

A spot meter is basically a light meter that measures reflected light only, and cannot be used for an incident reading. As its name implies, it has a very narrow angle of light acceptance—in some cases as little as 1°—as opposed to about 40° with a normal light meter. The spot meter is designed to be used with subjects that cannot be approached, and has a window that allows a direct view of the subject for accurate sighting. ● Built-in light meters are a feature of most modern cameras. Rangefinder cameras usually have the cell positioned to one side of the front element of the lens or near the viewfinder window, and the cell is linked to a read-out on the top plate of the camera. SLR cameras usually employ cells positioned inside the camera body and only register light entering the lens. All exposure information is visible in the viewfinder, allowing the camera operator to concentrate on composition without looking away to check exposure. There are three main types of TTL metering systems: averaged metering, centerweighted metering and spot metering.

Averaged metering cameras

measure the light from both the top and bottom of the viewfinder frame. They work on the assumption that in most pictures there is an equal amount of foreground and sky and are therefore ideal for the landscape photographer. If used in the portrait (vertical) format they are not as accurate.

Spot metering cameras are by far the most accurate of all the metering systems, and are to be found only on cameras manufactured in the past few years. They work on the same principle as hand-held spot meters, and measure light only from the very cenier of the screen. If your subject is not at the center, point the camera at your main subject, take a reading, set the exposure and then recompose your picture.

▲ Center-weighted metering cameras have, like the averaged metering system, two areas of sensitivity, one at the top and another at the bottom. But in this system the two areas overlap at the center of the viewfinder frame. The assumption with this system is that most people tend to position the object of most interest at the center of the picture.

Taking a light reading in a backlit scene can lead to exposure problems. The old rule about keeping the sun behind you when you compose a photograph does mostly work; but more interesting results can come from shooting into the sun. The problem in this type of situation is deciding what you are taking a picture of. In the shot below left, a light reading of the general scene led to a 2stop underexposure of the principal subject. In the shot below right, the light reading was taken from the girl's skin. This resulted in a slightly overexposed background but a correctly exposed main subject.

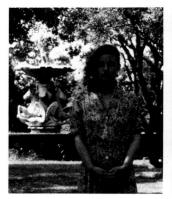

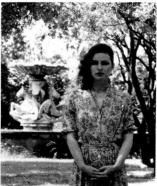

Lighting equipment

Indoor photography is most predictable when using tungsten lighting, as the effects of shadow and light, and their intensity, can be studied at leisure. When positioning lights use a dimmer switch to lower the light and heat output, prolonging lamp life and reducing discomfort.

- 1 Shallow-bowl reflector with cap
- 2 Flash umbrella
- 3 Standard reflector
- 4 Barn doors
- 5 Spotlight
- 6 Snoot
- 7 Studio flash

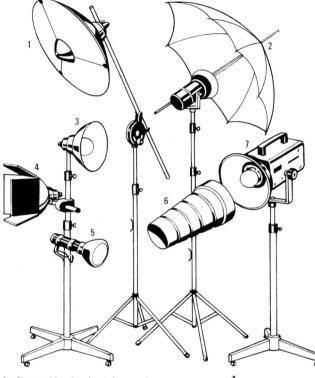

A reflector with a deep bowl shape produces rather a harsh lighting effect. While this might be suitable for male portraiture, for example, a shallow-bowl reflector, producing less-defiped shadows, is probably more flattering in general. A reflector with a matt finish will give a softer light overall than will a polished bowl reflector. To alter the spread of light, a funnel-shaped snoot can be clipped on. Two straight flaps, called barn doors, can be added to cut off the light from the picture edges. A single door is sometimes called a donkey.

Several different types of bulb are available to fit the various lamp holders and reflectors. The wattage of these lamps will affect their guide number—their light-emitting power. Guide numbers will also vary depending on the speed of film used. ● Electronic flashgun units are by far the cheapest and most portable type of artificial light source. A few non-electronic units are still available that take the old-style small clear or blue flash bulbs. The four-shot flash cubes are still used with many 126 and 110 format cameras.

Most electronic flashguns take from 4 to 20 seconds to recharge (or recycle) fully between pictures. Flash duration varies depending on type and may be as slow as 1/1000 or as fast as 1/50,000, so extremely fast action can be frozen irrespective of shutter speed. Many units are automatic and can be programmed just by dialling in your film speed and required aperture.

Some units also have a swivel foot so that you can bounce the light from the wall for a soft lighting effect. Others have tilting reflectors to bounce the light off the ceiling for the same soft effect. Yet other guns have a combination of swivel and tilt movements.

A few of the more complex amateur units even have accessories made for them as extras to vary the light quality. These may be colored filters for special mood lighting effects, or wide-angle diffusers to spread the light so that it corresponds to the angle of coverage of a wide-angle lens. When buying a flash unit with a swivel head, make sure its automatic light sensor will keep pointing straight at the subject regardless of where the head is directed.

- 1 Non-electronic flash
- 2 Flash cube
- 3 Front-swivelling flash
- 4 Tilting head flash
- 5 Clip-on reflector
- 6 Battery pack
- 7 Automatic flash with bounce head

High-power electronic flash units are available to both the professional and keen amateur which run off mains electricity and recycle quickly. Output of these units is often variable. Ringflash units, which produce a shadowless, even, bright light for close-ups, are also available.

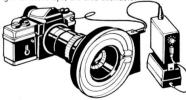

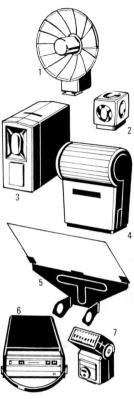

Holding the flash higher

and to one side gives better "modelling" (far left). Bouncing the light off a wall provides an even light (middle). Using the flash "on camera" (left) gives a flat effect.

Accessories

For slow shutter speeds or time exposures the camera needs to be attached to some form of support, and tripods, with pan and tilt heads and legs braced to a geared central column, offer the firmest support. A monopod or table-top tripod used with a cable release will provide a less steady but more transportable combination.

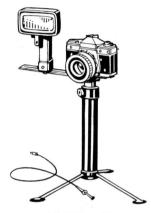

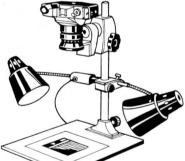

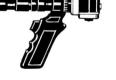

Photographs can be copied to produce a new negative when the negatives have been lost or damaged. A copying

been lost or damaged. A copying stand with two photofloods to provide even subject illumination is ideal for copying photographs and all forms of artwork, and many enlargers, once the head has been replaced by a camera, are perfectly adequate for this. The picture being copied must be kept completely flat and a small aperture, say f11, should be selected. If copying a color photograph use a tungsten light film that is color balanced for photofloods. Cropping is also possible at this stage.

✓ A pistol or rifle grip is a useful gadget when using a long lens. It provides a support near the centre of gravity of the camera and lens, allowing you a firmer hold on the camera/lens combination. A shutter release in the handle of the grip makes one-handed operation possible. As an aid to further increasing stability a shoulder harness can be attached to the grip. With this set-up shutter speeds as long as 1/4 should be possible. The majority of picture-taking situations can be catered for with only a modest selection of prime lenses—a wide-angle lens, a standard lens and a not-too-powerful telephoto lens. However, the situation sometimes demands a more specialized lens. There are many on the market, but if you are not likely to make constant use of these lenses it is worth considering renting as an alternative to buying.

1 A macro lens is designed to produce best results at extreme close range and can reproduce a subject up to life size. Macro lenses come in two basic focal lengths, 50 or 55 mm and 100 or 105 mm, and can be used for general photographic work.

Ž Á zoom lens has a variable focal length. This is achieved by constructing the internal elements so that some are movable and not fixed as in a normal lens.

3 A shift lens is a wide-angle lens designed for the 35 mm format. Part of the lens can be

moved off its axis and therefore has the ability to correct the perspective distortion known as

"converging verticals", common in architectural photography.

4 A bellows unit can be used with any lens to give a greatly magnified image, but a wide-angle lens is best because of its greater depth of field. This unit can provide greater-than-life-size magnification and infinitely variable magnification ratios.

5 A slide-copier is used in conjunction with a bellows unit to produce a duplicate slide or negative. A section of the original slide can be copied to fill the entire frame of the duplicate.

6 Extension tubes represent a cheaper alternative to the bellows. They provide a fixed distance separation between camera and lens for a fixed image magnification ratio. Extension tubes come in a set of three and can be used separately or in combination.

7 A lens hood fits over the front of a lens and prevents extraneous light from entering the lens and causing flare.

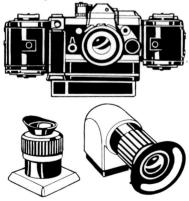

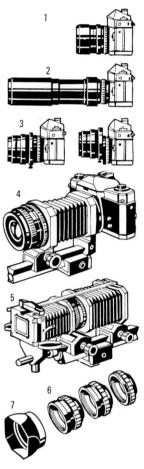

A motor drive unit is an expensive item, but is used by most sports and press photographers to provide quick film advance between frames. Some units operate at five frames per second (fps), but most autowinders operate at two fps.

A focusing magnifier,

which magnifies a small portion of the viewfinder's focusing screen, is very useful when accurate focusing is critical.

A right-angle finder is used when the camera is in an awkward position, for example when the camera is on a copying stand or-at ground level.

The studio/Design and equipment

For the keen still-life or portrait photographer, an area in the home set aside exclusively for equipment and models is desirable but probably impossible. But nearly any room, preferably with a north frontage, can be used as a pack-away studio. If permanent work surfaces are not practicable, then surfaces hinged to battens on the wall can be quite easily constructed. These can be fitted with collapsible or detachable legs, and when not in use the whole unit should sit neatly against the wall.

For most situations a selection of background papers, in a variety of lengths, widths and colors, is essential. These

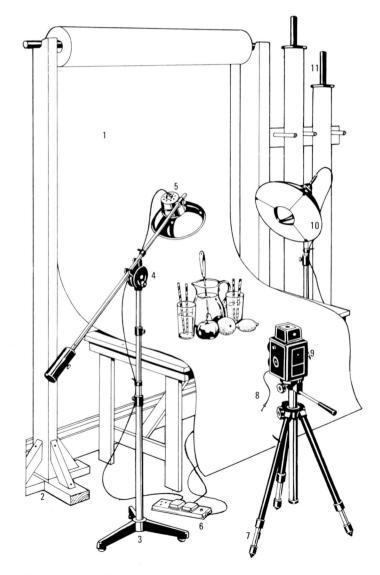

provide a plain, uncluttered backdrop against which to pose your subjects.

If you decide to go for small flash units instead of tungsten lights, try to avoid having extension leads trailing from unit to unit. If using daylight film, electronic flash can be supported by natural window light without presenting color balance problems, and subsidiary flashguns mounted on slave units will do away with the need for connecting cables. All this equipment, as well as one or two tripods and a flash umbrella, should pack away into a convenient cardboard box.

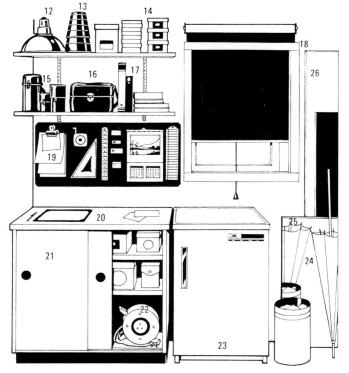

- 1 Background paper
- 2 Support
- 3 Adjustable stand
- 4 Boom arm
- 5 Shallow-bowl reflector
- 6 Three-plug extension
- 7 Tripod
- 8 Cable release
- 9 Twin-lens reflex camera
- 10 Shallow-bowl reflector with cap
- 11 Spare rolls of background paper
- 12 Standard reflector
- 13 Snoot
- 14 Storage containers

- 15 Assorted lens cases
- 16 Gadget bag
- 17 Files
- 18 Black-out blind
- 19 Notice board
- 20 Work surface
- 21 Storage area
- 22 Retractable extension lead
- 23 Refrigerator (for long-term
 - storage of films and photographic paper)
- 24 Reflecting flash umbrellas
- 25 Mirror
- 26 Background flats

Storage and care

As equipment, negatives and slides start to accumulate, some form of storage and presentation system is vital. From the numerous types of cases, bags, files and magazines you are sure to find one that suits your needs perfectly. Even if your requirements are modest at the moment, the best system to invest in is one that can be added to over the years, allowing you the possibility to expand.

Rigid cases with foam rubber inserts offer cameras and lenses the best protection. A lighter and cheaper alternative is the soft hold-all, but it is best to leave cameras, lenses and filters in their cases as an added protection against knocks. Always include as part of your kit a blower brush and lens cloth for on-the-spot cleaning of equipment.

E-1-0 01.3 01.2.2.

2/4/76

(2)

Once slide film has been processed it can be cut into single frames, which can be mounted in either cardboard or plastic holders. All relevant data, such as the date, place and perhaps exposure, can be noted at the top of the mount. Large numbers of slides can be filed in plastic sleeves and suspended in purpose-built filing drawers. Storing slides in projector magazines is the most convenient method, but this will become expensive as the number of slides increases. A definite aid to presentation is a small light box (a white-glass-topped frame with an internal, fluorescent, light source), on which slides can be viewed together and ordered for projection. Especially if using 35 mm format or smaller, a powerful magnifying glass is essential.

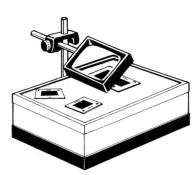

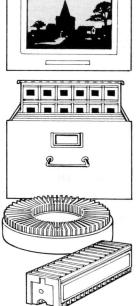

As a final check before loading slides into the projector a very convenient tool is the handviewer. These come in two basic types: viewers that need to be held up to the light to see the image and those with an internal light source (usually provided by two penlight batteries). For looking at a detail of a slide a small eyeglass is useful (these give approximately a x 8 magnification). Slide projector types are as varied as film formats. Most choice exists for those using 35 mm format film. If your budget is limited invest in a projector of modest specification only and use the money saved to buy the best possible lens. To project a large image in a limited space you will need a wide-angle lens, but if space is no problem a longer focal length lens can be used. The output of the projector lamp directly affects screen brightness, so ensure the lamp you buy is suitable for the viewing distance you will likely be using. As an additional extra some projectors can be fitted with a remote control device for automatic slide change and focusing. Any flat, white surface can be used to project pictures on to, but the most convenient surface is the fold-away projection screen. The screen is supported by a lightweight telescopic tripod and when collapsed the whole unit is very compact. The most reflective surface is the glass-beaded screen. This has minute glass beads incorporated on the surface, which reflect back nearly all the light falling on it. The problem with this type of screen is that the audience has to sit squarely in front of it. Strips of negatives need to be stored in a dry and cool environment or the emulsion will deteriorate. Special acid-free acetate sleeves are available to fit all film formats, which also ensure the successful long-term storage of negatives. Contact sheets and their corresponding negatives can be filed in ring-back folders. If storing slides in any form of box, try to include a packet of silica gel to absorb moisture.

0

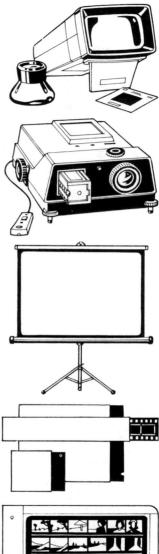

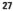

Film/Black and white film

Using the action of light to produce a permanent image was not possible until researchers in the latter half of the eighteenth century began to suspect that silver could be used for its image-forming properties.

Modern emulsions still use silver, or rather a compound of silver and a halogen (either iodine, bromine, chlorine or fluorine), which is later converted to metallic silver by the action of a developer. A thin layer of emulsion, containing the silver particles, is coated on to a plastic base. On the underside of the base is an anti-halation pigment, designed to stop light reflecting back from the near side of the film base.

The silver particles struck by the light entering the camera turn black when developed (representing highlight areas of the negative). Unaffected silver particles are removed during development, leaving the clear film base (representing shadow areas of the negative). At the printing stage, light from the enlarger shines through the clear sections of the negative and reacts with the silver compounds on the photographic paper; they turn black after development. But light cannot so easily pass through the developed silver of the negative, thus leaving the photographic paper white. The grains (clumps of silver compound) of a negative are always the same size: the lighter or darker gray areas are simply a variation in the concentration of silver halides.

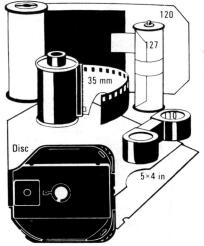

The most popular film format is 35mm. It comes in a metal or plastic cassette in either 24 or 36 exposure lengths. Convenient and easy to load, disc and 110 films come in plastic cartridges, which are broken open to free the film for processing. All disc films have 15 exposures, but 110 (and 126) film has either 12 or 20 exposures. One of the most popular roll films is 120. 127 roll film is narrower, producing a picture format 42 x 42 mm. For the serious amateur and professional. 5 x 4 in (12.7 x 10.2 cm) sheet film is available. It needs to be exposed in a studio or view camera and comes in boxes of 10 or 25.

After fix and wash

Four types of black and white

film, each with a different ASA rating, were used to produce the accompanying photographs. All shots were taken with a Pentax and 135mm lens with the aperture set at *f*4. Shutter speeds were varied to compensate for the films differing sensitivity to light. The first shot, taken with Pan F (50 ASA), shows the very fine grain response to be expected with this type of film. Skin tone is smooth and gradations of light and shade extensive.

A medium-grained film, Plus-X (125 ASA), was used for this second shot. Skin tone appears coarser than before. Depending on size of enlargement and viewing distance of the final print, 125. ASA is probably the fastest film that should be used for headand-shoulders portraiture.

Tri-X (400 ASA) film was used to take the next picture. Apart from a further deterioration in skin tone the photograph lacks the sharpness and bite of the first two and many of the half-tones have disappeared.

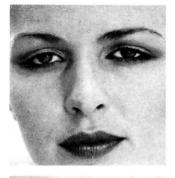

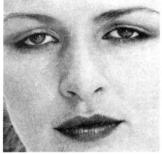

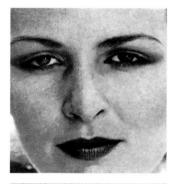

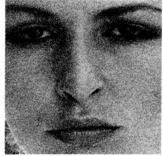

I used Tri-X uprated to 1600 ASA for the final exposure,

1600 ASA for the final exposure, and compensated for the underexposure by prolonging development. However, this has increased the grain size, breaking up the portrait image to an unacceptable degree. An alternative way to get extra speed without heavy grain is to use one of the relatively new "chromogenic" films. The main disadvantage of these films is that they must be developed like color negatives, using the C-41 process.

Film/Color film

White light is the source of all color, because it is a uniform mixture of all colored light wavelengths. Each color's light wavelength is measured in units called nanometers (one thousand millionth of a meter). The colors of the spectrum that are visible to the human eye range from deep purple (400 nanometers) to deep red (700 nanometers). Other light wavelengths such as infra-red and ultraviolet are actually outside the visible spectrum. Although the human eye cannot see ultraviolet light, films can "see" some light of this wavelength; this is why pictures taken in the shade or from a high altitude sometimes have a "cold" blue color cast. White light from the sun can be seen split into colors of the

White light from the sun can be seen split into colors of the visible spectrum by allowing it to pass through a prism-shaped block of glass and onto white paper. With another prism, all the colored light can be recombined into white light. We can see colors because objects reflect light of some wavelengths and absorb all others. A tomato reflects light of the red wavelength and absorbs other colors.

White light has three main or primary colors—blue, green and red. If you were to shine blue, green and red spotlights onto one surface, where all three overlap you will see white; where only two primary colors overlap, you will see a different color, for example red plus green equals yellow.

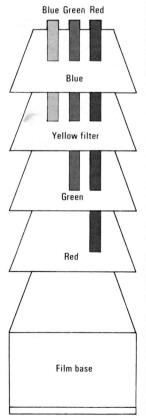

Basically, a color film is made of three layers of emulsion coated on a film base (see left). The tor emulsion layer responds to and records blue, the middle laver records green, and the last laver records red. Originally a color picture had to be made up from three different pictures-each made to record the red, green and yellow separately-which were combined for the total effect. With modern films this can be done with one exposure thanks to the carefully controlled multi-layer coating of film at the manufacturing stage. Color films do not respond exactly like human eyes; a face appears to be virtually the same color whether viewed in sunlight or indoors. by room lighting. But not to a slide film. It is designed to respond to colors as seen by light of a certain color temperature. Domestic tungsten lighting is more reddish than sunlight, which has a bluish quality. When using one type of film in the other light source, a color correcting filter must be used on the camera's lens.

Color negative films, however, do not need this extra filtration, since any color cast can be corrected when the print is being made.

By placing a yellow filter immediately under the blue emulsion layer, blue, and especially ultraviolet, light is prevented from affecting the green and red emulsion layers. This yellow filter layer is destroyed later during the processing sequence.

İnstant picture color films are broadly similar, except that the dry-process films have layers of color coupler and developer immediately below each color emulsion layer. When the print is ejected from the camera, pairs of rollers squeeze the alkaline developing agent into the different emulsion layers. Meanwhile, an opaque top layer prevents daylight from reaching the (as yet) undeveloped images. This layer clears upon full development and the developing agent then forms a white layer behind the color dye layers.

How color film works

Two main types of color film are available—one type provides a color negative from which a color print can later be made, and the other provides a direct color positive image, or transparency, for viewing by transmitted light. Only recently have manufacturers made color films (negative and transparency) with ASA ratings comparable with black and white emulsions.

Negative film

Color negative film basically consists of three layers. As can be seen in the diagram, right, when light enters the lens and strikes the film, the blue component of light is stopped by the first bluesensitive layer of the film. Green light is stopped by the second and red by the third. Yellow, for instance, being a mixture of green and red light, would be recorded by both the green and red layers but not by the blue. The action of light also forms a black silver image on development in all three layers. This is removed at the bleach and fix stage of processing. leaving the dyes incorporated In the layers unaffected. You have probably noticed that the color of the negatives are the complementaries of the colors in the original scene-blues appear yellow, greens appear magenta and reds appear cyan. This is because the blue-sensitive layer of the film carries yellow dye, the green-sensitive layer carries magenta dye and the red-sensitive layer carries cyan dye. The dve structure of the printing paper restores the colors of the original scene.

Transparency film

Transparency film must be exposed by a light source with a color temperature for which it was designed-tungsten, photoflood or daylight. Once the film is developed color faults cannot be rectified as they can with negative film. This is why exposure is of the greatest importance when shooting this type of film. Home-processing transparency film is now much simpler as new processing solutions only need to be kept at a little over room temperature. Transparency film is often called "reversal" because the image, once recorded (see right), must be reversed to restore the colors of the original scene. First the film is developed and then reversed (see below), followed by color development and bleach and fix stages

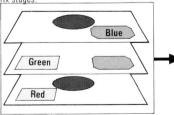

Reversing the image (above) can be achieved by re-exposing the film to light or by introducing a chemical agent in the color developer.

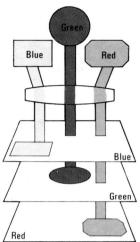

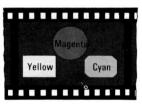

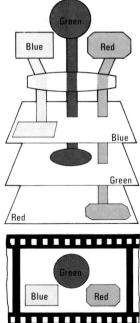

Color variables

There are many brands of color film on the market, each with its own characteristics. Some will give you a result that is very close to the original; others may be very far from it. You can see from the eight examples on the right how color can change depending on the film you use. The shots were all taken within a few minutes of each other under identical lighting conditions. Using a Pentax K2 set on automatic and a 50 mm lens. The difference is, however, only really apparent when you compare the results closely and for general use the results of most films are almost always acceptable. Remember, too, that processing can also make a huge difference to the result-if you had pieces of the same film developed in three different places you would end up with three distinctly different results. It is best to choose a film that suits your general requirements and to have it developed in the same place or process it yourself (see p.116). If home-processing, make sure you follow instructions to the letter, especially regarding time and temperature. It is interesting to note that different elements have come out better in different shots. The flesh tones are probably most successful in 1, the red in 6 and the blue of the flowers in 4. The best overall results have come from 1, 3, 6 and 7.

To get the best out of your color film use it within the datestamped time limit and store it in a cool, dry place. For longterm storage of film many professionals keep it in a sealed container in the refrigerator.

When projecting slides, to get true color make sure the projection lamp gives a clear white light and that the screen offers a clean white reflective surface.

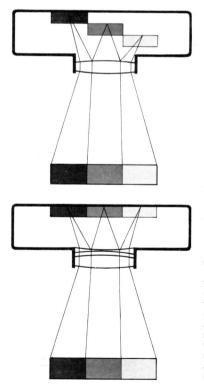

Chromatic aberration is a lens's inability to bring all the colored components of light into a single point of focus. White light, as we know from looking at the spectrum, can be split into seven main color components. As each component enters the lens it is refracted, or bent, to a different degree—much as a stick entering a pool from various angles seems to be bent to different degrees. The top diagram, left, shows light entering a simple camera lens. The red constituent of light comes to a point of focus at the rear film. plane, while the blue component is focused closest to the lens, with green falling between them. In a photograph, this type of lens would produce color fringes, especially noticeable around highlights. By using a type of lens called an achromatic doublet (lower diagram, left) the colors can all be brought into focus at the film plane. The achromatic doublet is constructed using two types of glass, each with a different refractive index (or ability to bend light). Strictly speaking, an achromatic doublet will only bring two colors to the same point of focus-usually blue and green. The third color, red, is already correctly focused.

1 Agfacolor CT21 (100 ASA)

3 Sakuracolor (100 ASA)

5 Agfachrome 50S (50 ASA)

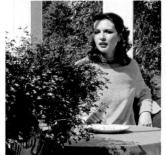

7 Ektachrome 64 (64 ASA)

2 Orwochrome (50 ASA)

4 Fuji 100RD (100 ASA)

6 Kodachrome 64 (64 ASA)

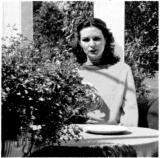

8 Ektachrome 200 (200 ASA)

Using the camera

Whenever possible it is best to load the camera indoors, where there is less possibility of grit or grime entering the delicate mechanisms exposed when the camera back is open or of stray light fogging the film. If the camera must be loaded outdoors, stand with your back to the wind to create a pocket of relatively still air. To safeguard against scratched negatives, do not remove the film from its sealed container until just before loading; dust can easily become lodged in the light-tight velvet trap of the cassette and thus cause long scratches or tracks when the film is advanced or, wound back.

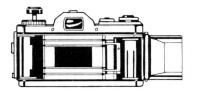

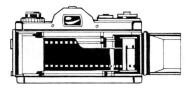

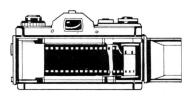

◀ Open the camera back and, before loading the film, inspect all the exposed surfaces for dust. Ensure the film guide rails and the film pressure plate (found on the back of the camera) are free from grit. Dust can be removed using a blower brush (preferably with the bristles removed) or with the ragged end of a torn lens tissue.

■ Remove the cassette from its sealed container and slot it into the camera compartment. Pull the tapered film-leader out and insert it into the take-up spool, making sure it is firmly attached. If the leader becomes free the film will not advance, and film will be wasted.

Once the film is firmly

secured on the take-up spool, advance the film, either manually or by moving the film-advance lever, until the leader disappears and the sprocket holes (both top and bottom) engage with the geared spool. Check to see the film is running square on the guide rails, close the back and advance the film twice.

To make the most of every picture-taking opportunity requires a degree of routine. A wrongly set film speed, a badly focused image or inadequate depth of field are a few of the factors resulting in disappointing photographs.

Ensure the film is winding on properly—the rewind handle should spin as you advance the film.

Set the ASA or DIN number on the camera's film speed dial or separate hand-held meter (see p.18).

Check there is enough power in your camera or light meter batteries.

Familiarize yourself with the type of metering system used in your camera or meter (see p.19).

Check highlight and shadow areas of the scene you want to photograph to ensure contrast range is not too much for the film to handle (see p.38).

Select shutter speed—ensure it is fast enough for handholding or use a camera support (see p.22).

Select aperture—if your camera has a stop-down button check to see if depth of field is adequate (see p.36).

Focus the image and shoot—bracketing exposures for important photographs.

Incorrect focusing and incorrect holding of the camera can result in very similar problems—indistinct and fuzzy images. Manufacturers of 35 mm system cameras produce a variety of different focusing screens to suit most tastes and circumstances, including microprism, split-image and ruled-grid screens, especially useful for ensuring verticals and horizontals are true in architectural photography. People with poor eyesight can fit correction lenses to the viewing window of the camera. Rangefinder cameras usually give you a secondary ghost image, which aligns with the main image to indicate the point of focus.

Eamera design usually dictates the most convenient way of holding and focusing the camera. Grip the camera securely, but not too tightly, with your right hand, leaving your index finger free to trigger the shutter release. Your left hand is now free to adjust not only the focus ring but also the aperture ring and shutter-speed ring or dial. Extra stability can be given to the camera if you press it lightly against your face. Once you have finished adjusting the camera's exposure and focusing, place your left hand, especially if using a long lens, under the lens to cradle some of the weight. At all times try to adopt a relaxed position.

Different positions demand different techniques. Crouching to take a picture does not differ markedly from the technique described above, but if you are using the camera in the vertical format, rest your right elbow on your knee for additional support, as shown above. Quite slow shutter speeds can be used if you can find a convenient wall or other support to lean against to stop your body swaying (see right).

Focusing and aperture

Out-of-focus pictures often result not from setting the focus ring at the incorrect mark but from camera shake. Lightweight 110 and 126 format cameras need careful handling as the slightest movement caused by depressing the shutter release results in blurred pictures.

There are occasions when critically sharp images are not desirable. Soft-focus lenses or lens attachments are available to intentionally diffuse an image, creating a more flattering photograph.

Both pictures below were taken at f1.2. For the first shot I focused on the eyes, and depth of field is so shallow the girl's hair is just out of focus. The second shot is deliberately out of focus to show how light and shade have merged.

For any lens there is only one point of true focus. Around this point is an area—known as the depth of field—where the image, although not in true focus, is acceptably sharp. Depth of field is variable and changes depending on the aperture and focal length. For the shot on the right I used an aperture of f2 on my 50 mm lens. Depth of field at this aperture only covers the girl.

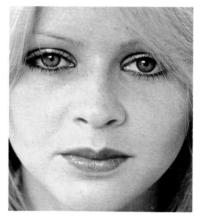

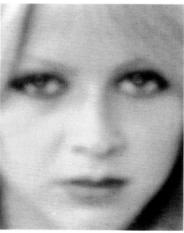

An aperture of /5.6 was used for the next shot, still using the same lens. It can be seen that at this smaller aperture more of the frame is acceptably sharp, with depth of field extending into the middle distance. This photograph and accompanying diagram illustrate the point that the smaller the aperture the greater the depth of field.

▶ Depth of field has been even further extended in this final photograph. Taken with the diaphragm closed down another two stops to /16, the picture shows that at this aperture depth of field ranges from only a few feet in front of the camera to infinity (see also diagram). It is possible with very wide-angle lenses not to bother with focusing at all, as the depth of field at every aperture is so extensive.

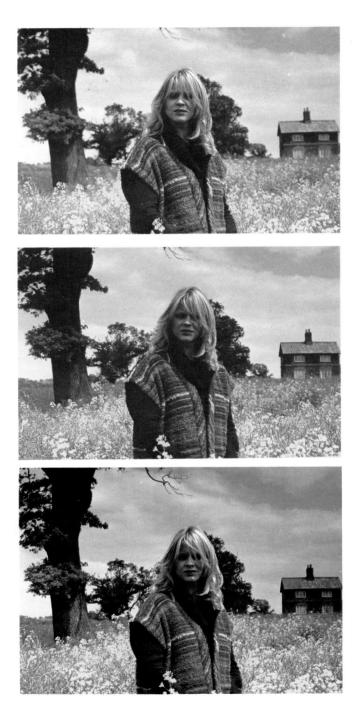

Exposing/Black and white

Gauging exposure is the most difficult task confronting the camera user not working with a fully automatic camera. Every photograph is a mixture of light and dark—highlight and shadow—and a light reading taken from one area alone can lead to serious exposure problems for the other.

Modern exposure meters (see p.18) —either selenium cell or CdS—can be relied upon to give accurate readings in most situations. They are at their best in flat, even lighting where there is minimal variation in tone or contrast. Problems arise, however, when a light reading taken from a highlight indicates more than a two-stop difference compared to a reading taken from a shadow area in the same scene. This type of situation is not all that uncommon and although the eye can easily cope with the contrast levels, it needs careful observation for you to be able to recognize scenes with contrast levels that might prove troublesome for the film you are using, and to compensate for them. Beach scenes in bright sunlight, indoor shots with strong sunlight filtering down through high windows, ground-level scenes overhung by leafy trees creating areas of intense shadow and bright all represent potential problems.

All film has some degree of contrast latitude—black and white negative film having the greatest range, followed by color negative film, with color reversal film needing the most accurate exposure—but once this two-stop difference between highlight and shadow is exceeded a decision usually has to be made either to expose for the shadows and allow the highlights to burn out, or to expose for the highlights and let the shadows become solid. (For tips on selective printing of enlargements see p.115.) A less contrasty scene will probably benefit from an averaged reading of highlight and shadow.

The two pictures opposite are good examples of high-contrast scenes where contrast itself has been used to create evocative images. I took the picture of the girl in a nightclub using available light only—a table-lamp. The contrast was already interesting so I exposed for the highlight in order to dramatize the face looming out of the darkness. Crisp winter-morning light and a dark-clad figure presented a dilemma in the picture below. Finally I decided to expose for the highlight and made a note to increase development by 50 per cent to extend contrast.

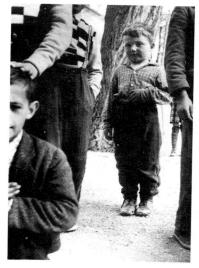

A situation may dictate your exposure. Not wanting to

disturb the mood of the group, left, I could not ask the boy I wanted to photograph to change his position to make the lighting effect more favorable. In this type of situation you can use an average reading to give some detail in both shadow and highlight areas, expose for the highlights and let the shadows go dark or expose for the shadows and burn out the highlights. I chose the last option and exposed for the shadowsthis gave detail in the clothes but meant that the face and the foreground burned out a little.

 Rolleiflex, 80 mm, HP5, 1/125, f8.

 Minolta, 135 mm, Tri-X, 1/30, f4.

 Nikon, 50 mm, Tri-X, 1|125, f8.

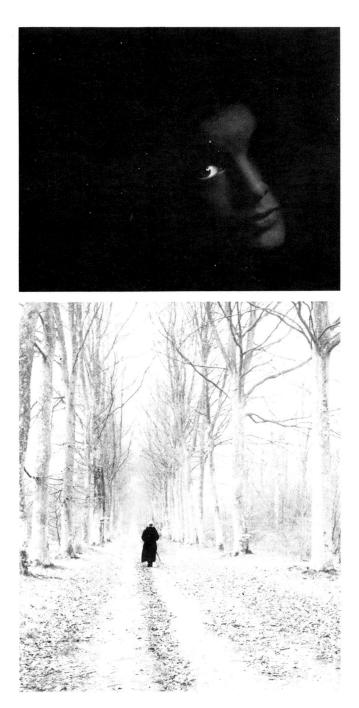

Exposing/Color

Exposing color film involves as much care as does exposing black and white film. Even professionals will admit to disasters in this area, and the problem is compounded by the fact that there is no *exact* exposure. Depending on whether you want a high-key or low-key picture, exposure, for the same subject, can vary by up to four or five stops between the brightest highlight and the deepest shadow. For a uniformly exposed picture, flat, even lighting is best as the one- or two-stop difference is well within the contrast range of negative film and just within the capabilities of slide film.

The seven exposures presented here show that varying the exposure affects not only definition and mood but also color. Three of the shots are acceptable, but the middle one is probably best, showing good detail in highlight and shadow. *Pentax*, 55 mm, Ektachrome 64, 11.2–116.

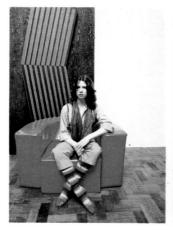

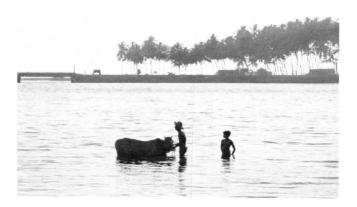

▶ Deliberate underexposure can be used for special effects. In the moonlit picture of a girl posing on a chair, right, underexposed two stops, so the delicate highlight reflected from her white lace dress seemed to glow in the darkened surroundings. Hasselblad, 80 mm, Ektachrome 64, 1/250, f16.

◆ Deliberate overexposure can also be used to make a more personal statement about your surroundings. When I came across the pair, left, watering and bathing their cow I was struck by the simplicity of the composition formed by their presence and the line of trees and buildings on the far shore. To avoid cluttering the picture with unnecessary detail I overexposed by three stops. Rolleiflex. 80 mm, Extachrome 64, 1/250, 18.

Principles of selection

When selecting subject matter for a photograph make sure you capture your point of interest in the simplest way and present it in such a way that it conveys the effect or emotion you are looking for. By your chosen angle of view, careful juxtaposition of images and attention to lighting you can create pictures to heighten the viewer's perception. Removing extraneous detail often gives greater impact to the subject. In many cases a detail speaks with greater intensity than a photograph of the whole subject: the wrestler, below, is a case in point. Here the tension of the struggle is conveyed by the selection of a detail expressive of the whole scene; we do not need to see the whole figures in the ring to be able to imagine them.

♥ By coming up close to the horse, below, instead of taking a standard middle-distance shot, I have given it stunning visual impact. Had I taken the shot from a greater distance the horse would have looked much less impressive and the eye would have been distracted by the landscape. I positioned the shot so the shape of the skyline echoes the back of the horse. Hasselblad, 60 mm, Tri-X, 1/125, f16.

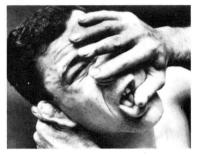

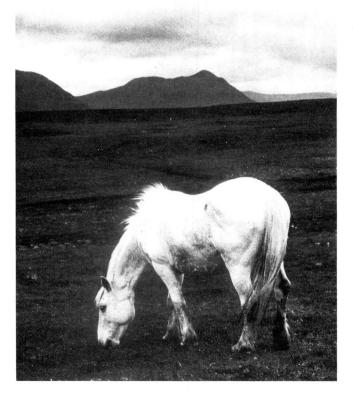

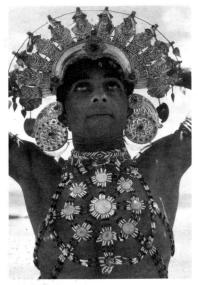

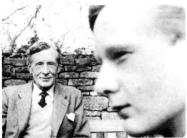

◆ A low viewpoint proved the most effective angle for this Singhalese dancer because it gave me an uncluttered background and a good view of the detail in his ornate headdress. Here the angle of the arms and the position of the eyes reinforce the emphasis on the unusual old intricate costume details. Rolleiflex, 80 mm, Plus-X, 1/250, f8.

Physical distance serves to draw attention to distance in years in the portrait of father and son, below left. I emphasized physical differences by keeping the boy in the foreground in soft focus, which shows off the smoothness of his young skin in contrast with the weatherbeaten, experienced face of the older man. Notice how the lines of the stone in the background echo the lines on his face. Hasselblad, 150 mm, Plus-X, 1/250, f5.6.

♥ Spontaneous actions can sometimes confound your careful selection of images, offering you something even more effective; you need to stay alert to all the possibilities. I was originally concentrating on the shadow cast by Henry Moore's sculpture, 'King and Queen'', below, when the sculptor himself walked by. His presence unified the group and added a new dimension to my first composition. Rolleiflex, 80 mm, Tri-X, 1/250, f16.

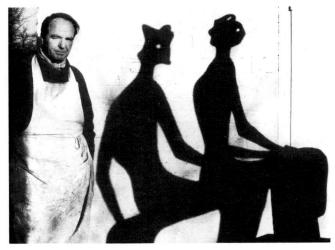

Composing

By arranging the elements of your picture you manipulate subject matter to express a particular point of view. Vertical lines take the eye into a picture; horizontals across it. By making full use of perspective you can get a three-dimensional feeling. Composition will vary depending on whether you are using black and white film stock or working in color.

● Time of day can influence composition; in the evening light, right, the long shadow emphasizes the figures and defines the area in which they are standing. The bright color against the somber background ensures that the isolated figures stand out. Pentax, 100 mm, Agfachrome 50S, 1/250, 18.

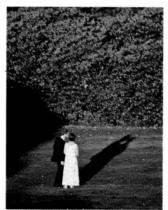

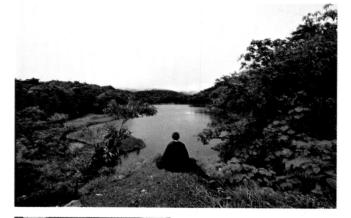

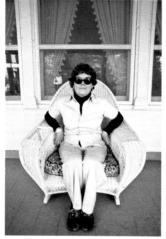

▲ The landscape dictated the positioning of the figure, above. The strong triangular silhouette in the foreground leads the eye forward into the heart of the landscape and the circular shape of the water takes the eye round the detail at the edges of the composition. Both shapes are strong visual elements in any composition; judicious use of such shapes can make your pictures much more interesting. Because the picture was taken in the rain there is poor saturation in the 505, 1/60, 111.

Objects can impose a certain composition. The wicker chair on the balcony, left, was under the window when the woman came and sat herself in it in a pose which at once echoed the symmetry of the composition but, in its rigidity, provided a contrast to the overall leisurely atmosphere. Leicaflex, 35 mm, Ektachrome 64, 1/60, f8.

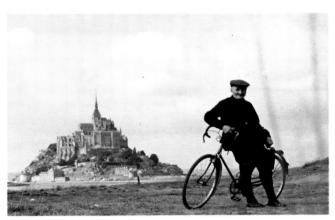

Harmony of shape unites the cyclist and the outline of Mont St Michel, above; this is further emphasized by the inverted pyramid of space between them. Contax, 35 mm, Ektachrome 64, 1/250, f11.

Close-ups need composing no less carefully than other shots. Your cropping decision depends on the mood you want to create, but by coming in close you need to generate some excitement or impact. In the picture of the mask, right, the shape of the face and the tusks has dictated the framing. *Pentax, 100 mm, Ektachrome* 64, 1/125, 111.

▼ To position a silhouette of the funeral procession, below, on the skyline, I lay in the grass because standing with the camera at eye level I lost the mourners behind the trees. Hasselblad, 80 mm, Ektachrome 64, 1/250, f8.

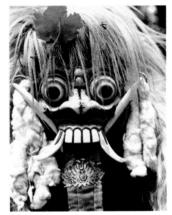

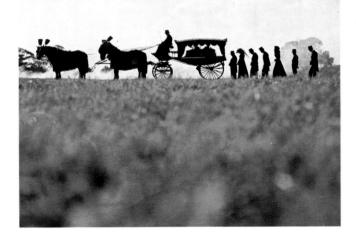

Background, middle distance and foreground

One of the best ways to produce a three-dimensional effect is to make calculated use of background, middle distance and foreground. If you can make a link between these areas of your photograph an illusion of depth will immediately be created. When composing try to organize the images so that the main subject is stressed and the others are played down.

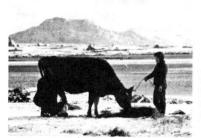

◆ The foreground can be used to dominate the picture, as in the photograph of the Hebridean scene, left. The strongest image in the picture is in the group with the cow, which firmly registers the importance of the foreground; middle distance and background fade away, bringing out the bleakness and isolation of the area. Vivitar 35EF, 28 mm, Plus. X, 1/260, f11.

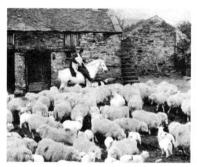

● A continuous link from foreground (sheep), through middle distance subject (shepherd) to background (stone walls) can be made by subject matter, texture and form. *Pentax, 28 mm, Plus-X, 1*/125. f8.

▼ Background is of primary importance here, although the chorister in the foreground provides a subject link with the chapel. Diminishing size creates a sense of distance and gives scale to the building. Hasselblad, 80 mm, Plus-X, 1/60, f11.

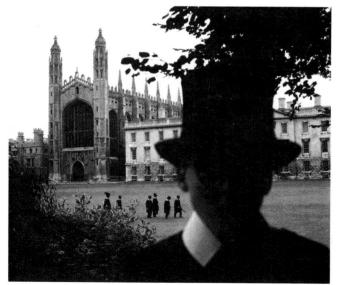

A simple device for linking foreground and distant subject matter is to shoot through a window, long grass, trees or a gate, as in the picture of Bombay, right. This gives a sense of perspective to the picture and can give a feeling of voyeurism to the viewer. It is very often used to good effect by professional photographers. Pentax, 50 mm, Plus. X, 1/250, f16.

All the elements in the photograph of Singapore Harbour, below, are of equal importance. Linking the old boats in the foreground to the skyscrapers behind is the river, which gives linear perspective to the picture, taking the eye right to the heart of it. This composition makes an interesting social comment on the contrast between the bustling, traditional life seen on the boats and the monied modern conditions reflected by the buildings behind. It is the selection and juxtaposition of such images that distinguishes the caring photographer, who will produce the really competent, aware photograph, from the casual snapshot merchant. Pentax, 28 mm, Plus-X, 1/125, f11.

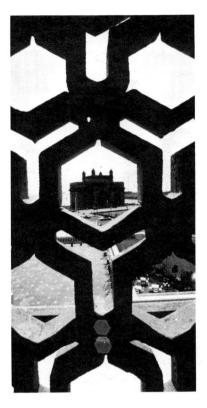

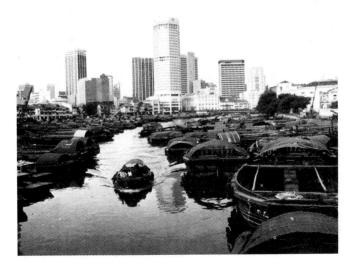

Shape, pattern, texture and form

You can find these elements in most photographs, whether they are highly subjective or simply serve as a record. To improve your understanding and appreciation of composition it helps to try to isolate and exaggerate these elements and to take some photographs that emphasize their individual qualities. Concentrate on one element at a time.

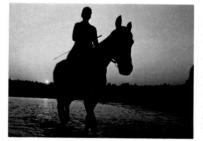

Shape has probably the strongest visual impact of all. Although there is no detail in this picture we have no difficulty in recognizing horse, rider or trees. The evening sun sets the mood and introduces enough color to evoke an emotional response. Outline and silhouette provide enough additional information. Leicaflex, 135 mm, Ektachrome 64, 1/125, f16.

● Pattern has a flattening effect on pictures, although there is some form in this palm leaf. Highlight and shadow have given surface interest to the leaf, but the predominant effect is one of a flat area of pattern. Pentax, 100 mm macro, Ektachrome 64, 1/125, f11.

♥ Repetition is not necessarily an ingredient of pattern; the effect can be kaleidoscopic, as in the range of fabrics, below. Although there is texture in the picture, it is dominated by large areas of color that produce the overall effect of a flat image. Pentax, 100 mm, Ektachrome 64, 1160, f11.

▶ All photographers strive to capture form, to give an impression not just of surface but of substance. Light the image to emphasize the direction of the form; diffused directional light is the most effective. Make sure the shadows are underneath, or you will produce an effect that does not look real. Contax, 135 mm, Ektachrome 160, 7160, f8.

Subtle form calls for subtle lighting. Contrast gives the illusion of depth; juxtapose hard and soft surfaces, plain and patterned, light and dark, bright and somber. The lighting of this textured binding emphasizes the quality of the form rather than the surface. *Pentax*, 100 nm, Ektachrome 64, 1/125, 18.

All the elements are balanced in this harmonious composition of a traditional pottery. All the shapes are easy to read and, although individual elements could have been photographed very differently, collectively they all show up well. Many people have an intuitive understanding of these basic elements, but it is often necessary to isolate them in order to respond to them individually. If you examine the photograph you can see how different areas could have been treated. Here there is nothing to distract the eye from the simple, continuous tonal range of color. Pentax, 28 mm, Ektachrome 200, 1/250, f16.

Texture is brought out by subtle lighting, oblique light will give you highlight and shadow, revealing the hidden qualities of the burnt wood, left, and the delicacy of the rose, above. Match the quality of light to the image; I needed a harsh light for the wood and a soft light for the rose. Pentax, 50 mm, Ektachrome 64, 1/250, f8. Minolta, 135 mm, Ektachrome 200, 1/250, f8.

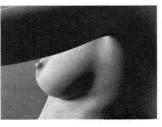

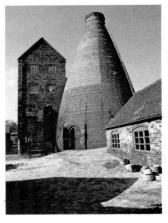

Step-by-step photography

If you have to dismantle complicated machinery, need to keep a record of intricate processes or have to give precise, step-by-step explanations, the camera is invaluable. The aim is to impart information and your technique should be correspondingly straightforward and consistent. Try to use uniform lighting, similar camera angles and the same film stock. Use a tripod and mark its position if you are photographing over a period of time. If you are taking slides for projection keep the image size constant as far as possible.

(All pictures) Pentax, 35 mm and 50 mm lenses. Ektachrome 64, around 1/125, f11.

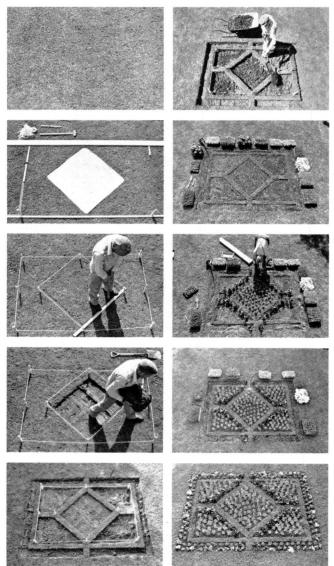

Time of day

Light changes color and intensity throughout the day and during the course of the seasons: it can alter the appearance of a building, picking out intricate details at one moment, obscuring prominent features the next. I photographed this isolated church on a summer's day to demonstrate the great variety in mood and composition that one location can offer.

◆ 7.00 am. Sunlight begins to filter through, giving weak directional light and slight modeling. (All pictures Pentax, Ektachrome 64); (left) 35 mm, 1/125, f8.

€ 8.30 am. The sun is a little stronger now even though there is still some cloud; it is giving greater modeling to the architecture and providing a strong contrast between the texture of the church wall and the foliage. I chose to come closer to the building than for the earlier picture, as the diffused sunlight was ideal, giving form and modeling to the façade. 50 mm, 1/125, 176.

● 10.30 am. The sun has now moved round to the south picking out the main porch. The intricate detail in the stonework is clearly defined and the rich color of the tiled roof shows up well. 100 mm, 1/250, f11.

♥ 12.30 am. In the midday light the main entrance can be seen to its best advantage. 35 mm, 1/250, f16.

● 2.30 pm. The sun moving toward the west throws light over the length of the building and the grassy graveyard, relating setting to church. Include some figures in shots of architecture as they lend a sense of scale. 28 mm, 1/250, f16.

♥ 3.30 pm. The afternoon sun on the tower made this the best time to capture its architectural detail. 28 mm, 1/250, f8.

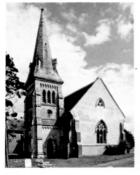

● 5.00 pm. As the light had started to fade by now I introduced some foliage into the composition to give some tonal contrast with the building. 28 mm, 1/250, 116.

▼ 7.00 pm. Rich evening light made this the best time to take the church from a distance to give an impression of its fertile agricultural environment. 35 mm, 1/125, f11.

▶ 9.00 pm. The intense color of the setting sun contrasts with the silhouette of the church, and all detail is lost. 400 mm, 1/500, 15.6.

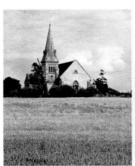

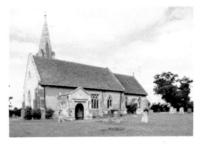

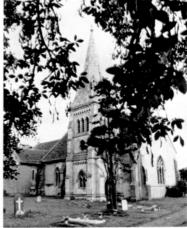

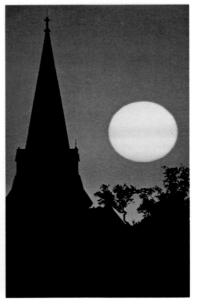

Weather

So many people take photographs in high summer in harsh midday sunlight. These conditions are bad for most things: early morning, late evening, cloud, and even rain and mist offer excellent possibilities. Use existing light to capture the prevailing atmosphere, as in the summer storm, right. Under these conditions, keep your camera ready for the fleeting rainbow. In fog or mist, familiar objects, like the boat, below, take on a new identity, with subdued colors and softened shapes; color film today can reproduce infinite subtleties

 Pentax, 135 mm, Ektachrome 64, 1/250, f 5.6.
 Leicaflex, 400 mm, Ektachrome 200, 1/250, f 8.

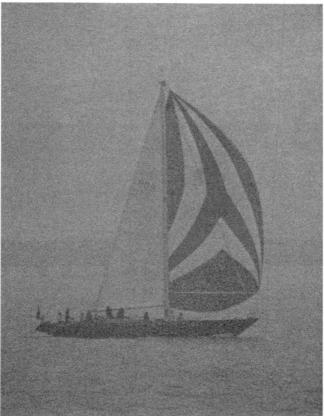

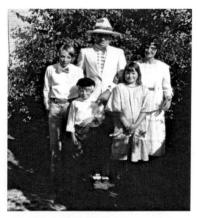

Harsh sunlight is not very flattering as this joke picture of a family group shows. It is particularly difficult to photograph people under these conditions All the eyes are squinting, the faces are almost obliterated, the shadows are hard and unkind and there is a general lack of detail. However the picture is effective in its own way because it is aiming to record the overall atmosphere of a hot summer day rather than to portray a group of individuals. Minolta, 55 mm, Ektachrome 64, 1/500.f11.

Make the most of rain

because it brings life and brightness to dull surfaces like roads and roofs; the leaves, left, have become shiny and reflective. Shelter under an umbrella and don't worry if your camera gets a little wet—but dry it as soon as possible. *Pentax*, *100 mm, Ektachrome 64, 1/60, f4.*

♥ When photographing in snow, take a light reading off your hand or gray card, as you may be misled by light bouncing off the snow. Use a UV filter to cut haze and produce crisp outlines. Choose viewpoints that offer a contrast; here you have hard rocks and soft clouds. *Minolta*, 135 mm, *Ektachrome* 64, 1/500, 116.

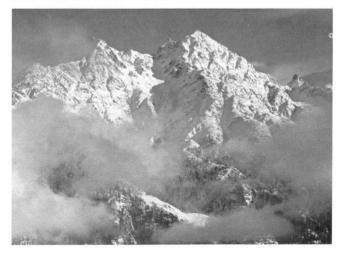

Strong natural light

While it is very sound general advice to keep the sun to one side behind your shoulder, shooting into the sun or back-lighting can give you an exciting explosion of light. However, if you include the point source of light it burns out and desaturates all colors; if you expose for this the rest of the picture will be in darkness; the trick is to make sure the sun is judiciously positioned behind an appropriate object—failing this, make it an integral part of the picture. Take light readings at right angles to the light source to get comparative densities.

Sunset or sunrise is the best time to use the sun as back-lighting, when it is low enough to be partly obscured by the people or objects in your photograph. To take the girl, right, lexposed to give good detail in the shadow area, allowing the light to burn out her head. *Minolta*, 55 mm, Ektachrome 64, 1/125, f 5.6.

▼ The point source of light has been lost in the glowing portrait of a teaching monk, below, but light from the setting sun has flooded into the room and reflected back on the people in it. To capture the detail indoors I took a light reading from the middle boy's shirt. When you are shooting in reflected light, the colors come closer together. *Rolleitlex*, 55 mm, *Ektachrome* 200, 1/60, f2.8.

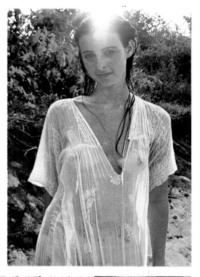

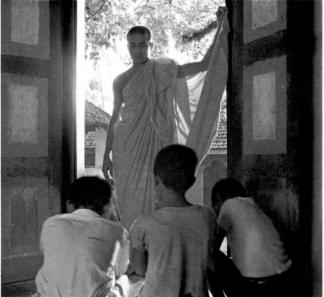

The way light falls on an object can completely change its color and appearance. These two pictures of balloons were taken within minutes of each other but in opposite directions. Above, the light falling on the balloon makes everything in the picture, including the basket, very sharp and brings out the strong colors and the contrast with the bright blue sky. Below, the color is much weaker, the detail is lost and the emphasis is on the silhouette. The color is particularly subdued here because the light is going through two thicknesses of material. Pentax, 100 mm, Ektachrome 64, (above) 1/250, f11, (below) 1/500, f16.

♥ Brilliant sun will flare into the camera lens and give ghost images of the iris diaphragm on the film if you shoot toward it. You can see this in the camera and shoot accordingly (it will reduce image quality). Remember that it is very dangerous for your eyes to point your camera at the sun. Rolleiflex, 55 mm, Ektachrome 64, 11250, f8.

Color filters

A few of the many color filters available can be seen grouped on the right. Used alone or in combination they can remove reflections, penetrate haze, give color spot or graduated effects, or balance film stock to light source. For details of color and special effects filters see, pages 125-6.

S Taken without a filter this straightforward picture of a yacht at anchor, left, is a good example of the type of picture that can benefit from filters designed to alter both color and atmosphere. All pictures were taken within a few minutes using a Pentax, 55 mm, Ektachrome 64, 1/250, f8. For each exposure only one filter was used, but to multiply the effects more than one filter can be used.

The green and yellow dualcolored filter used for the picture on the left makes no concession to reality, and its very strong, unnatural coloration tends to swamp the subject. I positioned the filter so that most of the yacht appeared against the yellow and not the stronger green. Also, the yellow produced a better horizon effect than did the green.

◆ The graduated filter used left is dark brown at the top, becoming lighter toward the center of the frame. The other half of the filter is clear glass. I used this filter in order to add a little atmosphere to a rather featureless expanse of blue sky, making it appear much more ominous and threatening than it did in the first picture. I could have rotated the filter to reverse the color effect.

A diffusion (or soft-focus) filter

has subtly helped to change the atmosphere of this version of the photograph, without adding any exaggerated color effects. This filter has a clear central area, so anything positioned at the middle of the frame is not affected. The wider the aperture the greater the effect. You can get the same effect by smearing grease or petroleum jelly on a plain glass filter.

A colored filter with a clear central spot leaves the middle of the frame as it would appear naturally, but produces a colored vignette at the edges. Apart from funneling attention to the center of the picture, it also implies that the yacht is being observed from the circular porthole of another vessel. As with the dual-color filter used above, the effect of the color-spot filter is limited. ● A "colorburst" diffraction filter was used (right) to change this straightforward street scene into a multitude of dazzling lights. This filter does not need any exposure adjustment as it does not exclude any light. Its kaleidoscopic effect comes from its ability to split light into its separate colors. Nikkormat, 50 mm, Ektachrome 200, 1/60, f5.6, "colorburst" filter.

Without the addition of a "variostarburst" filter, the shot of a darkened headland (right) would have appeared flat and uninteresting. Instead, this filter has picked out the brightest point sources of light and spread their rays into brilliant star patterns, giving a point of interest to the composition and balancing an otherwise featureless frame. Pentax, 55 mm, Ektachrome 200, 1/30, 14.

The two photographs above show the effect of a polarizing filter. In the first shot a confusion of main image partially obscured by prominent reflections can be seen. For the second shot I attached a polarizing filter and rotated it until most of the reflections had been eliminated. Because this filter does remove some light, a two-stop exposure adjustment was necessary to avoid underexposure.

● Infra-red light (right) produces. bizarre color distortions in familiar objects. An infra-red transmitting filter can be used to block the longer wavelengths of light, and because the effects of this type of film are unpredictable, a strong yellow filter should be used to generally warm up the colors. Vegetation tends to reproduce as magenta, reds go yellow, skin tones go greenish and blacks go maroon.

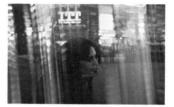

Mixing light

You can greatly extend the range of creative opportunities of color photography if you experiment with different types of film in different types of lighting. Daylight film is matched to daylight at noon and has a blue quality; used in artificial light it increases the orange and gives a warm effect. Tungsten film is matched to artificial light and becomes bluish in daylight. The normal procedure is to select your film according to which kind of light predominates. In a daylit room, for instance, a small area under a table-lamp can become a beautiful orange highlight if shot with daylight-balanced film.

● Daylight film has given a warm glow to the interior, left, because it was lit by artificial light. You can, however, see the daylight, which is bluer, through the window. This shot and the two below show how you can vary the appearance of the same scene by using different film in different conditions. (All pictures) Pentax, 21 mm, (left) Ektachrome 200, 1/15, f16.

◀ Tungsten film has rendered the same interior much greener. It was taken in the same lighting conditions. The light is now much nearer the true color but there is a predominant cast, which gives a rather chilly atmosphere. Ektachrome 160, 1/15, 111.

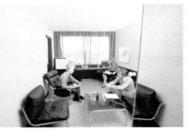

✓ Electronic flash matched to daylight film has given the truest result in available light. However, each of the three pictures on its own would probably be considered acceptable. *Ektachrome 200, f16.*

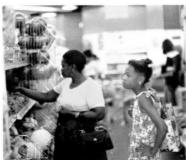

● Fluorescent lighting does not really present problems even though it restricts the color range. There are filters available to correct the color balance, but I consider the difference so slight it is hardly worth using them. Remember to use daylight film if in white (natural) light, artificial light film if in yellow or pinkish (artificial) light. This will give you an acceptable color rendering of most subjects you will encounter. Pentax, 55 mm, Ektachrome 64, 1/30, 14:

▶ Dramatic effects can be achieved with fireworks or other moving lights if you hold the shutter open for a while. Here I captured the effect of several rockets at once by exposing for 18 seconds, during which time they were set off continuously. I covered the lens between rockets to avoid the intrusion of local light. Pentax, 35 mm, Ektachrome 64, 18 sec, ff6.

▼ To capture the movement of the car lights at dusk, below, I put the camera on a tripod and waited for the car to move off. I calculated that it would take 30 seconds for the car to pass me and adjusted the aperture accordingly. Rolleiflex, 80 mm, Ektachrome 64, 30 sec. f16.

Available light

While it is true to say that any photograph taken without supplementary lighting is taken in available light, we usually mean by this term pictures taken in poor light and without flash. The advantages are that you capture more of the atmosphere and get a more subtle light: flash tends to give a harsh light in the immediate area, throwing the rest of the picture into darkness.

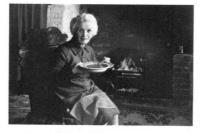

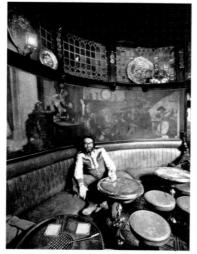

◆ Firelight can be soft and flattering as it is in the portrait, left, where it is combined with side-lighting to bring out the detail. By exposing for the shadows I have made the room look much lighter than it was. People look and feel relaxed in available light and are not disturbed by the unnatural brightness of flash. Pentax, 50 mm, Agfachrome 505, 1/30, 18.

A shaft of light can be used to pick out the subject. The poet Adrian Henri, left, stands out of dark surroundings, where the colors offer no reflected light. Take advantage of available light in all public interiors, particularly where people are performing or speaking, so you do not distract or disturb anyone. Pentax, 28 mm, Ektachrome 200, 1/15, f4.

♥ Gloomy light often produces pictures rich in fully saturated colors. Notice how this girl's eyes and teeth gleam and how the low light level has contributed to her lack of self-consciousness. I positioned her head in a gap in the busy background and exposed for the highlights. Pentax, 55 mm, Ektachrome 200, 1130. 14.

● Candlelight is quite harsh, but the movement of the flames gives a softened effect. You can also get interesting pictures that are a faithful record of what the eye sees by using the light of a match or torch. *Vivitar*, 50 mm, *Ektachrome* 160, 1/15, 12.8.

♥ Modern film can capture subtle detail in a poorly lit subject; notice the quality of this boy's skin and trousers, textures barely visible with the eye. Fast film and fast lenses are often a great asset; don't make the mistake of not taking them because you are going to a hot climate. Pentax, 28 mm, Ektachrome 200, 1/30, 14.

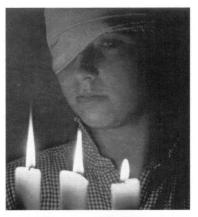

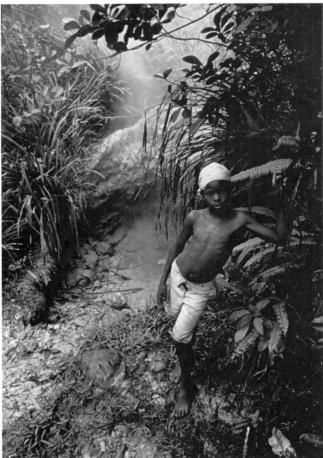

Photographing the subject

Each photograph you take should have an individual point of view; this does not mean that you will want to look for a contrived effect but simply that you should examine all the possibilities of the subject and come up with the most appropriate interpretation. Spend as much time as you can before you shoot, looking hard and exploring alternative viewpoints; consider different lighting arrangements and details of composition. Very often quite commonplace objects or events can be given a new significance by the angle of view that you choose, the juxtaposition of unexpected images or a revealing emphasis of detail. Consider also time of day and the effects of light and shade as a creative device.

◆ Always be on the look-out for the unexpected. The photograph, left, has a bizarre quality due to the cat's apparent relaxation in the snow. The camera angle for the cat and its home was achieved by my lying flat on the ground in the snow. Pentax, 55 mm, Ektachrome 200, 1/250, f8.

The appropriateness of the image below made me take this photograph of a wine-growing estate reflected in a glass of the wine produced there. By inverting the order in which one would expect to see the images, I stressed the importance of the produce. Mamiya, 180 mm, Ektachrome 64, 1/250, f8.

▶ Time of day can sometimes be used to introduce an unexpected element. To photograph this rugged castle in its romantic setting I got up at dawn to capture the early morning mist and deserted landscape and get a romantic effect. In places frequented by tourists it is always a good idea to have an early start before people and cars arrive. *Contax, 135 mm, Tri-X, 1/250, f8.*

▶ By obscuring the face you depersonalize the human form. By placing the girl, right, behind the lampshade, I have made her body simply one of several intriguing elements in this composition. Pentax, 35 mm, Plus-X, 1/15, f8.

♥ By drawing attention to significant features you can highlight important aspects of a person's life and work. Barbara Hepworth, below, was sitting under a roof light with her hands highlighted when I came to photograph her. I emphasized them further by using a wide-angle lens. Hasselblad, 50 mm, Tri-X, 1/30, f8.

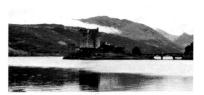

Still life

You can learn a lot from still-life photography; working with inanimate objects gives you complete control over composition and lighting. Plan your shot, then collect more objects than you aim to use; build around the largest or most interesting. Always check the effect through the camera. Plain or textured backgrounds are best. Use simple lighting for a threedimensional aspect with shadows going in one direction: diffused daylight with a white card reflector, or one light, possibly with a bounced fill-in light to soften shadows and give detail. Use a tripod and slower fine-grain film. Shutter speed is not critical so try to get everything sharp by using a small aperture.

Glass is fascinating to photograph as it is so responsive to lighting conditions. Here are two straightforward ways to treat it. The bottles and glass below have been back-lit by light bounced off the wall behind to give a silhouette, with a sidelight and reflector to add detail. In the composition, bottom, I used a side-light with a curved reflector on the opposite side to give delicate high-key reflections. Sometimes simply using available light from a window gives the most satisfying and subtle effects. Remember that glass demands a very accurate exposure. Linhof, 100 mm, Tri-X, (below) 1 sec., f22, (bottom) 4 sec., f16.

Simple shapes such as the basket, right, show how a tonal range can give the illusion of form. Here a soft directional light with a reflector has provided the necessary modeling. By aiming for a negative of medium contrast you will get a wide range of control when printing. Linhof, 100 mm, Plus-X, 1 sec., f32. In composite still-life pictures the objects should relate to each other ; they may be of similar shape or color, belong to the same period, or, as with the bookbinding equipment, below, to the same trade. I used daylight and a reflector here, but a photoflood behind a white sheet would have done. Linhof, 65 mm, Plus-X,

12 sec., f16.

Food

For photography food should be in peak condition. Fruit and vegetables should be hand-picked; if you want to cut them in half do it just at the last moment. Remember that lights and sunlight dry food out, so turn on lights at the last minute or, if possible, use electronic flash. Cook food for about two-thirds of the usual cooking time so that shapes are retained and then photograph immediately. For a shiny appetizing surface brush with oil or glycerine, where appropriate. If a dish might spoil, use a substitute while you finalize details of composition and lighting; when you are taking the real thing you must work quickly.

For complicated shots work out your composition first. You can use a background for a special effect in a way that complements the food and extends the possibilities of still-life photography (see below, right). However, it is usually best to use a plain background that does not compete with the food. Select props that harmonize in color and shape. If your photograph cuts into objects in the foreground you will give a feeling of immediacy. Einhof, 65 mm, Ektachrome 64, f16, Balcar electronic flash. MPP. 80 mm. Ektachrome 64. 3 sec., f16.

▲ A single dish can show all the subtleties of good cooking. Be careful not to get shadows of yourself or your camera in the way. For close-ups I underexpose ½ stop on transparency film for greater color saturation. *Pentax*. 100 mm, Agfachrome 50S, 1/30, f5.6.

● Food prepared for special occasions deserves to be recorded. The time you spend on lighting and composing the shot should reflect the time and effort that has gone into the cooking and preparation. Diffused daylight is good for dishes that are subsequently to be eaten. The best flat surface is the floor; get up above your composition on a stepladder. Pentax, 35 mm, Agfachrome 50S, 1/30, f5.6.

Food makes a good prop for pictures of children. The boy. left, photographed at his birthday party, was quite unselfconscious as he played with the candles on his cake. For this type of shot it is useful to use flash to arrest movement; here I managed to get the effect of diffused daylight by using a flash reflected off a white sheet with another white sheet used to give fill-in light. If possible, always position the flash near a source of natural light to avoid cross-shadows Rolleiflex, 55 mm, Ektachrome 64. 1/60. f8.

68

Studio portraits

The first consideration of portrait photography is to bring out character. Lighting, though all-important, is secondary. Where appropriate use soft directional light for a flattering effect. North light is ideal. Talk to your sitter to establish a relationship; if possible, let people continue their work as you photograph them.

Sometimes unconventional lighting, as in the portrait of Henry Moore, right, can be effective. I wanted to capture his mood of concentration and let the back-lighting emphasize the strength and sensitivity of his hands. *Hasselblad*, *150 mm, Tri-X*, *1*/*125*, *15.6*.

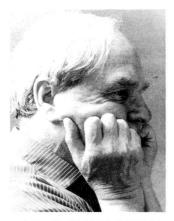

Light from a single point source

can be overwhelmingly harsh. To photograph Basil Spence, above, at his drawing board, in the light of an Anglepoise lamp, I turned the light to the wall to put him in reflected light and to reduce contrast. *Pentax, 55 mm, Tri-X, 1/30, 12.*

● Both girl and guitar are important in the portrait, left. Here dramatic lighting suggests a stage performance: I lit a gray paper background from the side with a diffused 1000-watt spotlight; white studio walls provided fill-in light, giving detail in shadow areas and lessening contrast. It was worth taking some time to arrange this shot so that the girl was comfortable and could sing in a relaxed way. *Hasselblad, 80 mm, Tri-X, 1/25, f8.*

Faces can be used for emphasis, as in the magazine photograph, right, where the eyes, looking down, draw the viewer's attention away from the face and toward the brooch. The strong frontal lighting minimizes the features so that the symmetry of the composition is immediately noticeable. Beauty photographs are very often lit in this way as frontal lighting eliminates skin flaws. l used a black velvet background and put the girl in a black velvet cape to absorb all light. When you need to double expose. black velvet absorbs the most light. Hasselblad, 150 mm, Tri-X, f16, Balcar electronic flash with a white umbrella next to the camera.

In the studio of William Scott the painter, above, I noticed that the light on the various white surfaces gave different shades of gray, an effect characteristic of his work at the time. To give the impression he was superimposed on one of his canvases, I photographed him behind a door. Bronica, 80 mm, Tri-X, 1/60, f8. I posed the two close friends, right, in front of a window and stood in front of them, careful not to block the light. For lively and spontaneous pictures, put the camera on a tripod so you don't have to talk to people from behind the camera. Bronica. 80 mm, Tri-X, 1/60, f8.

Portraits out of doors

When photographing people out of doors, it is necessary to give greater emphasis to the person than to the environment. Then, if you have selected an appropriate angle, or by using selective focusing, you can combine both elements successfully. The characteristic portrait of Graham Sutherland, right, was taken while he was studying the light on a thornbush. The tangled undergrowth and the dappled light contribute to an atmosphere of quiet contemplation but do not compete with the artist. More uniform lighting would have highlighted unwanted detail.

Relationships in shape and

color can form interesting links between subject and background. I photographed the poet Adrian Henri outside the house where he was born, above, in evening light. This produced a blue cast in shadow areas and emphasized the blues behind and in his clothes. By sheer coincidence there are also strong similarities between the shapes on the building and on his clothes. *Pentax, 100 mm, Ektachrome 64, 130, f8.*

Props can be used to tell a story. I photographed the former Archbishop of Canterbury, Dr Fisher, after he retired; the wicker chair seemed to express his increased leisure time, while its style lent dignity. Rolleiflex, 50 mm, Ektachrome 64, 11,125, 18. ▶ A formal pose can be made more interesting by the angle from which you shoot and the introduction of other elements to contribute to the story. I shot from a diving board to get a clear background for the contest winner, right. *Minolta*, 35 mm, Agfachrome 50S, 1/250, 15.6.

♥ Looking straight into the camera draws the viewer's attention as in the compelling portrait of two Malayan dancers, below. Tropical vegetation provided a suitable background against which to contrast the subtle skin tone. Pentax, 100 mm, Ektachrome 64, 1/125, f8.

Natural poses are a help to the photographer. The gardener, right, adopted this stance as we chatted and as it expressed his personality and aspects of his work I asked him to hold it. I exposed for shadow detail, which enabled me to capture his rugged complexion. Shooting slightly against the light can give interesting modeling in portrait photography, although, of course, if you shoot directly against the light you may get little more than a silhouette. This effect is helped here by the pyramid composition, in which the man's face forms the center of interest. Rolleiflex, 50 mm, Ektachrome 64. 1/60. f8.

Portrait variations

Seeing how many different character pictures you can get of the same person is a good exercise in portrait photography. Actors and actresses make good subjects as they are unselfconscious in front of the camera. You can easily get hold of.props such as wigs, false beards, moustaches and glasses at theatrical costumiers. Try them in different permutations and let the sitter assume an appropriate pose for each. Use soft, directional light and a plain background for additional flexibility. (All pictures) Hasselblad, 150 mm, HP5, f16, electronic flash.

Character portraits

If you possess a camera with fast lenses, i.e. *f*1.2-*f*2.8, and use fast film, you will be able to do portraits indoors in existing light. This is very useful as you may find that there is nowhere else available but in any case your subject will always feel more relaxed at home or in a familiar situation. This applies particularly to elderly people and young children. Often a tripod is desirable for shots of 1/15-1 sec. or more—this will enable you to get photographs with relatively little light. If you haven't got one on hand you can wedge your camera against a wall or rest it on a suitable surface. Practise at home, with your own family.

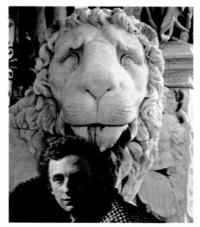

An intriguing effect has been achieved in the portrait of Patrick Proctor, left, by combining the subject, lit from the left by an Anglepoise lamp, with a poster of the Arsenale in Venice, which was taken with lighting from the right. The relative size of the images adds to the interest of the composition. Their juxtaposition is particularly appropriate as Venice inspires much of the artist's work. Had I been unable to find an appropriate poster of Venice I could have achieved a similar effect with front projection (see p.98). Vivitar 35EF. automatic, Ektachrome 64.

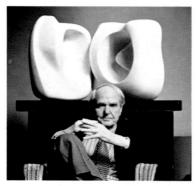

● Hand-holding the camera was possible, in the portrait of Henry Moore, left, as his studio was a very light working space. I photographed him as he was relaxing after finishing some drawings. The different colors you can see in the background add interest to the composition; the walls were painted different colors for the sculptor to view his work in various situations. Rolleiflex, 80 mm, Ektachrome 64, 1/125, f8.

• To photograph old people (Mrs Aida Rowe, left, was 113) you should leave them in their own surroundings: don't disturb them with a lot of equipment and bright lights. The old lady's room was small and dark, so I used a tripod and a time exposure. This gave very faithful color. *Rolleiflex*, 80 mm, Ektachrome 64, 2 sec., 14. ▶ Color casts, such as the yellow glow, right, can create an atmosphere; here the excitement of a party in a marquee. If I had tried to filter it out I would have got artificial color and lost the real record of the event. As it is, the warm glow over the whole picture reinforces the boy's party mood and cheerful expression. Pentax, 55 mm, Ektachrome 64, 1/30, 72.

▶ Light rooms with white walls give a perfectly even, balanced light suitable for flattering portraits. There is plenty of modeling but little shadow in the gentle portrait of the girl, right. Beauty shots are often taken in similar situations. Hasselblad, 150 mm, Ektachrome 64, 1/250, 18.

♥ Harsh midday sunlight is usually bad for portraits. However, it gave appropriate modeling to the Zulu woman, below, and brought out the rich colors in her costume. Rolleiflex, 80 mm, Ektachrome 64, 1/250, f16.

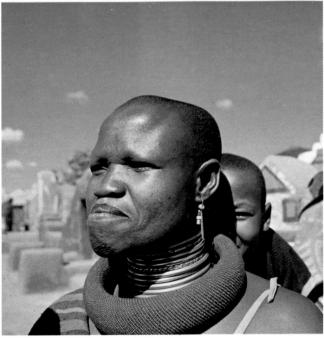

Nudes

Photographing the nude gives you the opportunity to show form in many different ways, from the abstract to the sensuous. Lighting is the key to the mood you create.

For inexperienced models use natural light as I have in the gentle portrait of a pregnant woman, right.

Details of the human body can form dramatic and unusual compositions. The hand, below, emerging from and returning to darkness gives a surreal effect. Normally light should follow the shape of the body, but breaking the flow of the form by shadow can produce interesting results.

interesting results. Linhof, 80 mm, Tri-X, 1/30, f5.6.

♥ Hasselblad, 150 mm, Royal-X, 1/30, f5.6, illumination from a 100-watt electric light bulb.

▶ To bring an element of

chance into nude photography it is worth experimenting with electronic flash as I did here, or using a slow shutter exposure to capture some movement. You can also get interesting results from out-of-focus images, where the image moves across the picture or towards the camera, or by using reflections. Settings for nudes can range from the highly ornate and evocative to the plainest possible background with no props at all, right. Whether the result is romantic or purely abstract is very much up to the photographer, who, in this kind of photography, has enormous scope for bringing in his own ideas. For a spontaneous effect like this you must use models who are quite unselfconscious without clothes and who move well. Hasselblad, 80 mm, Tri-X, f11, Balcar electronic flash.

Controlled lighting has separated the planes, right, and subtle variation in lighting between figure and background has brought out the form. I used two diffused floodlights next to the camera and two more on the background behind the figure. Hasselblad, 150 mm, Tri-X, 1/60, f5.6.

▼ The provocative study, below, was taken in early morning light, which has given tremendous clarity to the corn and wild flowers as well as sharp form to the body. To create a romantic atmosphere I could have used soft-focus filters or petroleum jelly. MPP, 180 mm, Tri-X, 1/250, f11.

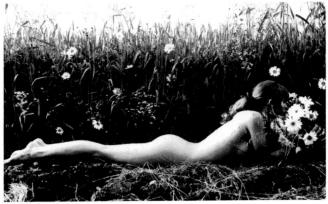

Children

Children are among the most difficult but most rewarding of subjects for photography. The main problem is persuading them to keep still, so rule out elaborate lighting systems and prefocusing. To give them the freedom to move around use overall lighting such as photofloods reflected off a white ceiling or sheet. Flash can be useful but don't fire it into a child's face as it can be both frightening and distracting. Remember that children get bored easily and may not want to participate for more than a few minutes at a time, so keep your camera handy and loaded with fast film for non-flash pictures.

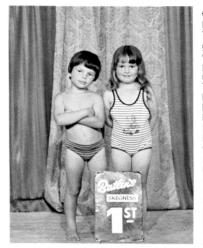

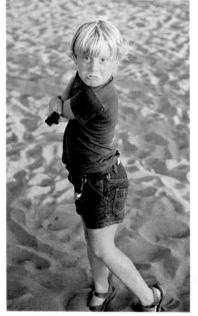

Special events in children's lives should always be recorded. To get the best results at prizegivings and other ceremonies you will have to behave like a press photographer-proud parents are unlikely to be refused permission. Try to include some of the background or general setting to bring out the atmosphere and to help you remember the event in later years. The card in front of the beauty contest winners, left, tells the story of the event. Because the children were posed I could use a relatively slow exposure in the existing light, which was a mixture of fluorescent light and spotlights that reproduced the atmosphere of the event much better than flash would have done. Vivitar 35EF, automatic, Ektachrome 64.

Fleeting expressions have to be captured quickly and it is sometimes impossible to focus accurately or to work out the exposure in time. It is better to get the picture even if it is slightly out of focus than to lose the moment altogether. In my haste to catch the boy's grimace, left, I cut off part of his feet. Remember that keeping a real record of your children involves all the temper and tears as well as the smiles and happy moments. Pentax, 50 mm, Ektachrome 64, 1/250, f4

Set everything up in advance for studio shots so you don't keep children waiting and try to keep them amused. Even so you may find a young model walks out on you as mine did here, providing me with an interesting character shot. However, after behaving badly for some time, he suddenly decided, as often happens, to be thoroughly co-operative. Mamiya, 135 mm, Agfachrome 50L, f16, electronic flash.

Babies are happiest when they are nude and free to kick and wriggle, so this is a good time to take pictures of them. Apart from close-ups of faces, which all parents want, it is interesting to record stages of development and involvement with surrounding objects. Keep backgrounds clear and don't include anything not relevant to the picture; in the light nursery, right, all I needed to do was take a picture off the wall to create an ideal setting for this relaxed picture. Vivitar 35EF, automatic, Ektachrome 64.

By kneeling down you can take children at their own level and often get a clearer background as well. The boys, right, were quite happy to pose because they had a new toy. By using a wideangle lens I made the boy in the foreground, who was taking the lead in the game, look more dominant than the boy behind. The striped sweater emphasized this effect. Shooting in diffused evening sunlight against a shadow area has provided good contrast. Rollei, 55 mm, Ektachrome 64, 1/250, f2.8.

Groups and events

Social and sporting events account for so many photographs that it is always worth doing some homework first. Go to the location, look at the space available, color and lighting conditions, and appropriate backgrounds; make sure you have permission to photograph if necessary. Use fast film and lenses of appropriate focal length and position yourself so you do not distract the people you are photographing.

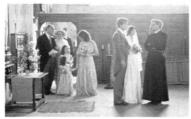

Special moments such as the blessing (top) can only be captured if nobody is disturbed. I positioned myself out of sight and used a wide-angle lens.

Informal moments, such as preparing to leave the church (above left), are often the best. When people are concentrating on their role in the event they are unlikely to feel self-conscious.

€ Group shots are a must but they need not be rigid and lifeless. I find the moments just before and just after the 'official'' pose give the best results—leave two or three exposures to use when the group thinks you have finished. Pentax, 28 mm, Ektachrome 200, (first 2) 1/30, f3.5, (third) 1/500, f11.

Close-ups are an important part of the record of any event. I photographed the bride, left, while she was arranging her veil in a mirror. As she was concentrating on what she was doing she did not feel—and consequently did not look—selfconscious. My 135 mm lens enabled me to take the picture without getting in her way. Use a long lens for this purpose or to isolate detail in a crowd from a distance. *Pentax*, *135 mm*, *Ektachrome 200*, *1*/*125*, *f2.5*:

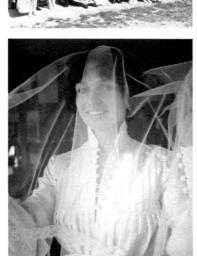

• Let people pose themselves and you will get an informal picture. Although the composition is formal the mood of the participants is relaxed. Vivitar 35EF, automatic, Ektachrome 64.

Sporting events offer dramatic subjects who are not inhibited by the camera. To isolate the skater, right, I chose a slow shutter speed and panned; that gave the feeling of movement and obliterated an irrelevant background. To capture the atmosphere of the hunting scene, below, I compressed the group by using a longer lens. Pentax, 100 mm, Ektachrome 200, 1/30, panned, f16. Pentax, 135 mm, Ektachrome 200, 1/250, f11.

Travel

You will be more comfortable if you travel light, but try to be prepared for most eventualities. Use a strong camera bag and take 3 lenses, if you have them, lens cleansing material, lots of film, a spare battery for your meter and a supply of plastic bags. Make notes on all the shots you take-including general historical or geographical information as well as all the relevant technical details. When you return don't have all your film processed at once-send some out for testing first to make sure there is nothing wrong that could be corrected in the processing Even traditional tourist spots taken with family groups can have an individual feeling, as in this humorous picture of Pisa, right, Pentax, 35 mm, Ektachrome 64, 1/250, f8,

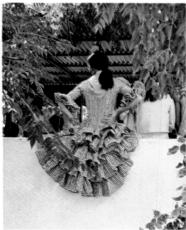

Don't avoid the obvious

angle just for the sake of it; the view of St Mark's in Venice, above, is taken from a picture postcard point of view, but using a wide-angle lens has given greater depth to the picture, suggesting the bustling atmosphere of a busy city. Pentax, 28 mm, Kodachrome II, 1130, f11.

◆ An untypical view of a typical Spanish dress. I photographed this girl as she was waiting to take part in the parade at the annual sherry festival in Jerez. It is not easy to see the shape of the dress with the dancer in motion, but this casual pose captures its form perfectly. Leicallex, 90 mm, Ektachrome 64, 1/250, f8.

► Close-ups of people can successfully convey the atmosphere of a foreign country. You will find that most people are not too reluctant to have pictures taken of them : however, this Balinese dancer positively welcomed the idea because he had taken a lot of time and trouble with his make-up. Pentax, 100 mm, Ektachrome 64, 1/125, f8.

♥ Shooting from unusual positions is often effective don't be put off by the amused reactions of onlookers if you need to lie flat on your stomach as I did to take this Sri-Lankan dancer. Contax, 50 mm, Ektachrome 64, 1/250, f11.

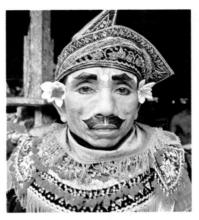

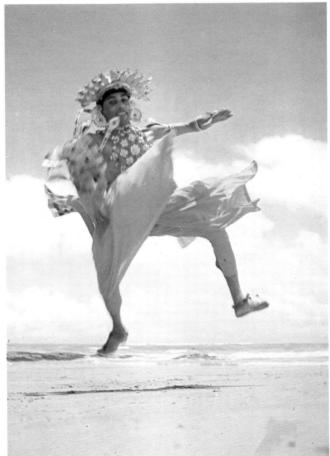

Vacations

Vacation pictures should record all the spontaneous fun of the event, becoming lively snapshots. Try to have your camera with you at all times so that you do not miss the right moment and so your companions get used to you photographing them. You will not always be able to get uncluttered backgrounds so remember that a low camera angle can often minimize problem backgrounds, as in the picture of the girl balancing on the beach ball, right. It has also made her achievement seem the greater.

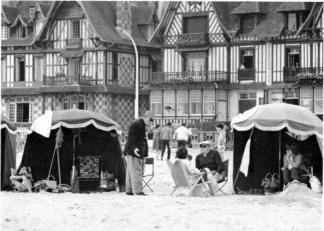

▲ Use a long lens to capture local scenes such as the spirited conversation between two families on the beach at Deauville, above. By taking the picture in this way I was able to emphasize the setting and to catch the people at an unguarded moment. *Pentax, 100 mm, Ektachrome 64, 1/125, f8.*

Add interest to pictures of children by capturing some background detail. The boat behind the child, right, is in fact being sailed by his brother. I might have used a long lens to close up the two images, but as I only had a fixed-lens camera to hand I made the best of the composition by placing the boy in the foreground so the sea linked the images. Vivitar 35EF, automatic, Ektachrome 64.

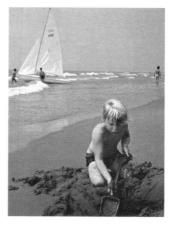

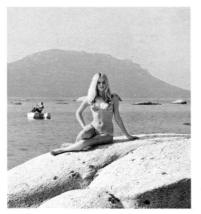

Strong sunlight is not ideal for most pictures but it can be made to work for you. In the classic holiday pose, left, I made sure the light was coming from the side to give good modeling to the girl's body and left her face in the shadow so she could look straight out without squinting. The light rock reflected light in shadow areas. I had to photograph the girl below when the light was in the wrong position. In such cases it is always better to capture the cheerful atmosphere than to worry about slight faults in technique.

 ✓ Practika, 50 mm, Agfachrome 50S, 1/500, f5.6.
 ✓ Vivitar 35EF, Ektachrome 64.

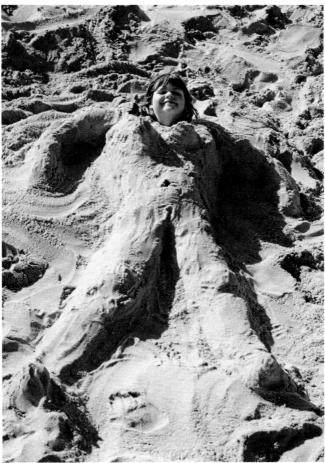

Seaside

Seaside pictures are usually taken when you are on vacation. Make the most of this opportunity to take photographs that are more than just vacation snapshots. Observe your surroundings; watch the changing light, the movement of the water, reflections and the effect of weather conditions in general. Keep your camera ready at all times to capture the unusual and unexpected. Not an obvious vacation shot, this silhouette of a girl on the beach makes an interesting portrait. The girl's stance, the strength of the shapes and the subtle range of sunset colors reflected in the wet sand combine to evoke a powerful atmosphere. Pentax, 100 mm, Ektachrome 200, 1/30, f4, with tripod.

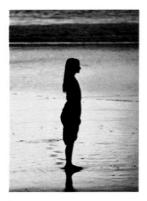

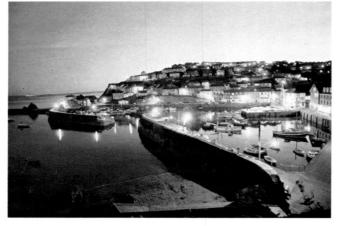

Dusk is an excellent time to take photographs; use daylight or artificial light film according to which light predominates. Select your viewpoint so as not to leave whole areas in darkness and include some areas artificially lit to give a warm atmosphere. For long exposures of stationary objects rest your camera on a wall as I did to photograph this fishing village. Pentax, 28 mm, Ektachrome 200 (daylight), 5 sec., f6.3.

Take sunset shots about a quarter of an hour after the sun has disappeared, when the sky is at its most brilliant. At this time you will be able to pick up detail in the shadows. Expose for a combination of highlight and shadow. Rolleiflex, 55 mm, Ektachrome 64, 11/25, 18.

● For water sports use a long lens, pre-focus and wait until the peak of the action. The surfer was taken hand-held at sufficiently fast speed to stop camera movement and arrest the action. Pentax, 200 mm, Ektachrome 64, 1/500, f8.

♥ After a light shower these wooden breakwaters reflected the coloring of the sky and water. Shooting from the dark to the light increased the feeling of distance in this composition. None the less, there is still a seaside atmosphere. Vivitar 35EF, automatic, Ektachrome 64.

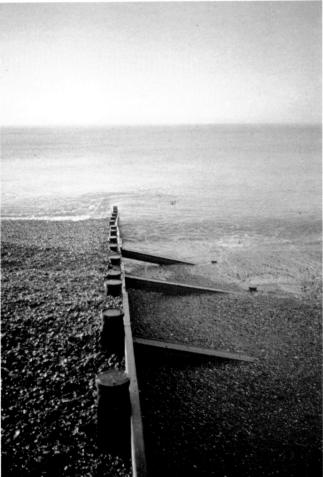

Nature and landscape

◀ Landscape compositions need a focal point and a sense of perspective. Here the eye is drawn into the picture by the scale of the haystacks, upwards by the church haystacks, upwards by the church spire and across the landscape by the strong horizontal lines. Note the '' aerial perspective'' — where color diminishes as background recedes. Pentax, 28 mm, Ektachrome 200, 1/250, f8.

● Defying the conventions of landscape photography, this photograph of barren territory in Western Australia shows off the weird shapes of the eroded earth and the extraordinary way in which the sky echoes them. I avoided introducing a dominant subject for this reason. Leicaflex, 21 mm, Ektachrome 64, 11000. f8.

Backgrounds like the lakeside, left, are ideal as they are rich in color, shape and atmosphere and not overimposing. Here the central figure dominates and lends scale to the landscape. Leicaflex, 90 mm, Ektachrome 200, 1/1000. f8.

● An aerial view of English countryside where shadows cast by the setting sun are the strongest images. Reflections from aircraft windows often spoil such pictures, bur you can avoid these by hanging a dark jacket behind your head. *Minolta, 55 mm, Ektachrome 64,* 1/250, f8.

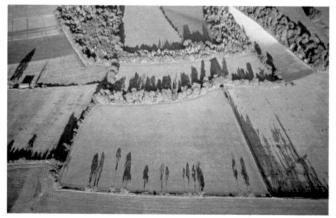

✓ For flowers you can use most cameras capable of focusing to 0.5 m (1 yd) or close-up extension tubes, but a 100 mm macro lens is best. The problems can be lack of light and movement caused by wind. A white or silver reflector can reflect more light on to the flower and a wire stake will help prevent movement. Angle of view is often hard to establish; look all round the flower or take alternative views. Choose the widest possible aperture to isolate the flower from its complicated background. Pentax, 100 mm, Ektachrome 64, 1/125, f5.6.

▼ Formal subjects, such as this Italian garden, below, need treating in a precise and straightforward way. An extreme wide-angle lens emphasizes scale and perspective. An overcast day has brought out the intensity in the greens. Pentax, 15 mm, Ektachrome 200, 1/250, f8.

Water and underwater

You can buy elaborate equipment for underwater photography, but it is possible to achieve spectacular effects by just using an underwater camera such as a Nikonos in existing light. Waterproof cases for ordinary cameras are available, but since salt water will ruin your camera it is obviously wise to invest in the best possible protection; these cases are really only for shallow-water photography. It is best to use a wide-angle lens underwater as the angle of view is reduced by the refractive effect of water, and you can minimize this effect by getting closer to your subject. For the brightest light and the most interesting scenes you need tropical waters; in other climates flash is essential below about 5 m (15 ft).

◆ Practise focusing and exposure by going to a diving school or a place where fish are fed regularly and are used to the proximity of humans. Nikonos, 35 mm, Ektachrome 200, electronic flash, 1/30, f16.

♥ Remember that the seashore, such as this area of the Barrier Reef with its coral and rockpools, can yield hundreds of exciting subjects for photography with an ordinary camera (but interchangeable lenses are a must). Pentax, 50 mm, 1/500, UV filter.

▶ Reflected in the water the brightly painted boats, right, offer an ever-changing abstract composition. Moving water is always interesting whether you take it on its own with strong reflections, or introduce other subjects. Pentax, 100 mm, Ektachrome 64, 1/250, f11.

▶ Silhouette reflections of reeds taken against the light make an interesting pattern and describe the surface and quality of the water. Good reflections are seen in the early morning and evening when the sun is low and the water still. For rich color, underexpose $\frac{1}{2}$ -1 stop on slide film. *Pentax*, 100 mm, Ektachrome 64, 1/250, 111.

▼ To arrest the movement of the water and still capture the energetic action of the boys swimming, I used a medium-fast shutter speed. Note how, the quality of water can vary in one small area. Pentax, 100 mm, Ektachrome 64, 1/125, f8.

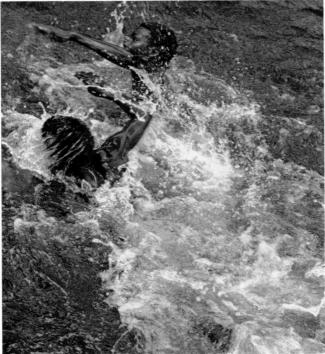

Animals in the wild

You need patience and a lot of understanding to photograph animals successfully in their natural surroundings. Get information from experts if necessary. You may need to build a hide or shoot from a car or a tent. Remote-control cameras, long lenses and tripods are all invaluable. Try to position yourself so you get an uncluttered background; failing this use selective focusing. Make use of available light as supplementary lighting is usually difficult.

Small, fast-moving creatures like this tree frog need a photographer who works quickly. Shooting at open aperture diffuses the background and isolates the image. I focused by moving the camera. Leicaflex, 135 mm, Agfachrome 50S, 1/2000, widest aperture.

♥ I took two days to photograph this fox. It often helps to put out a little food for a few days before you photograph. In this case we let out some chickens and I got my pictures, though the fox was not so lucky. For this sort of picture you must shoot at very fast speeds. Minolta, 55 mm, Ektachrome 200, 1/500, f11.

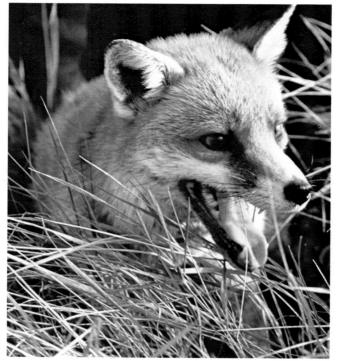

▶ The seagull, right, was photographed from a boat. Because both boat and bird were travelling in the same direction at a similar speed, and the bird was gliding on the wind, I was able to take the picture at 1/60. The only limitation on shutter speed was the necessity of avoiding camera shake. Leicaflex, 90 mm, Kodachrome II, 1/60, 18.

Nests are difficult to photograph in sufficient light. Here a 100 mm macro is invaluable; open aperture and minimal depth of field are an advantage in this case as they bring out the seclusion and snugness of the nest. Pentax, 100 mm macro, Ektachrome 200, 1/30, if 4.

Baby birds, such as the morthen, below, demand extra patience. I waited 3 hours for this picture at the side of a pond; after an hour the birds felt free to come quite close to me. Continual refocusing and assessing light is necessary for this sort of shot. *Pentar, 200 mm, Ektachrome 200, 1/250, f4.*

Pets and zoo animals

▲ A long lens (90 mm or longer) will enable you to eliminate wire netting or bars at the zoo. If you focus sharply on the bird or animal and then shoot at open aperture the bars will disappear, as they have in this picture of a parrot. The color has retained its brilliance although it is slightly diffused. Leicaflex, 135 mm, Ektachrome 64, 1/250, f4.

♥ Pets, like people, have a personality to express. Use objects familiar to them as props. Here the dog's bed both reassures him and provides an excellent color contrast. Electronic flash is a help as it arrests movement and enables you to take pictures without problems of overheating floodlights. Hasselblad, 150 mm, Ektachrome 64, 116, Balcar electronic flash.

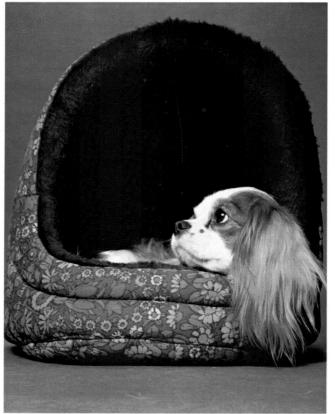

Overcast skies can bring out a rich quality that bright sun might burn out. The pattern on this bird's wing and the overall modeling show up beautifully here. Lack of light restricted the aperture and speed, but the feeling of movement and strength is enhanced. When photographing animals you should always be alert to the possibilities of interesting and unexpected movements and be able to respond to the situation very quickly. I had already worked out the technical details of the shot when the bird suddenly spread its wings revealing a marvelously rich new area of pattern and texture. Pentax, 50mm, Tri-X, 1/60, f2.8.

Small animals are best
 photographed with SLRs, which
 give you ease of focusing and
 action—necessary with fast moving animals.
 Although this picture of a cat
 looks bright it was taken in
 subdued lighting; this was
 deliberate in order to make the
 eyes appear brighter. Pentax,
 100 mm, Tri-X, 1/125, 14.

E Zoo animals are often easier to photograph because they are used to people, but it can be very difficult in some zoos to get a natural-looking uncluttered background. The photographer is at the mercy of the animals and must wait until they take up the sort of pose he is looking for. These black swans were taken first thing in the morning when you can be sure there will be few people about. Notice that I positioned myself to shoot slightly against the light; this was in order to bring out the texture of their feathers, which would otherwise have appeared solid black. Vivitar 35EF automatic, Tri-X.

Studio techniques

Almost any combination of images can be achieved in studio conditions, often with a limited amount of equipment, and it is not hard-to select certain areas and mask out others (see pp.114-15). However. simple, well-thought-out combinations are usually the most successful. As well as being fun to do these images can combine subjects you could not possibly have photographed together and they can also provide a disturbingly different view of the familiar. To photograph a model in a location that you have on slide but cannot get to, simply project the background image on to a screen, as shown right, position the model in front of it, light from one side and shoot both images together. (See details below.)

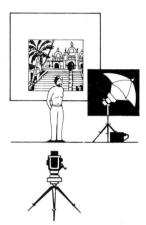

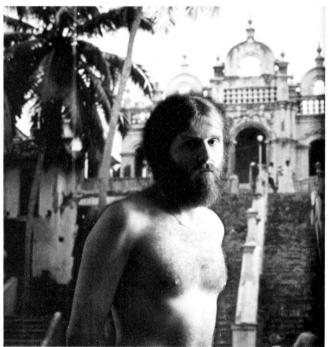

▲ Front projection has set the London student above in an exotic Indian location. This technique requires the image axis of the projector to be identical to the lens axis of the camera. Position the projector parallel to the screen and bounce the image off a semi-silvered mirror, set at an angle of 45°, on to it. Behind the mirror, position the camera so that its lens exactly aligns with the redirected image. Use a highly reflective, glass-beaded screen to throw back a bright image and to make any unwanted image falling on the model appear dim in comparison. Light the model separately to kill the image. If all angles are correct the model in front of the screen should always mask his or her own shadow.

✓ The effect of a zoom lens can be produced in the studio. For the picture left | projected the image on to a flat white-painted wall, placed the camera with a zoom lens behind the projector and changed focal length during the exposure. As you can see it is impossible to tell that the picture was not originally shot with a zoom. *Vivitar*, 70-210 mm, Tri-X, 1/4, 1/5.6.

▼ Multiple images, such as the dramatic shot below, can be achieved by using two projectors (diagram below). I used the mouth alone as the main shot and superimposed a double exposure on it. To take the full face and profile I used a black velvet background and exposed separately for each image, lighting the face in each case from one direction only. *Hasselblad, 150 mm, Tri-X, 1/15, 18.*

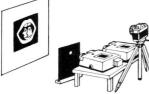

■ Using two projectors, I first projected the shot of the mouth; with the other projector I positioned the double exposure of the girl's head in the darkened area in the center of the picture and photographed the screen to get the final image. You can vary the size of the final image by moving the projectors in relation to the screen.

Studio techniques

Troboscopic lights can give exciting multiple images. It is usually necessary to have a black, or at any rate a dark, background so that the images show up clearly-they tend to burn out in light backgrounds. Best results are obtained when flashes are fired relatively slowly (about 10 per second) as too many superimposed images can give a muddled effect. It used to be the case that you needed a complicated set-up to achieve the right effect, but stroboscopic lamps with variable controls-up to 20 flashes per second—are now available : you can use these to give any number of flashes during an exposure and time the frequency to suit the movement you are recording. To get clearly defined images of the belly dancer below I used 5 flashes per second. Rolleiflex, 80 mm, Tri-X, f16.

▶ Television or cinema screens provide an unending source of potential images. To photograph a television screen you should use a shutter speed no faster than 1/30 because the picture on the tube is re-formed many times a second and you will need to have several scans during the exposure in order to record the complete image successfully. If using color film it is best to choose the type balanced for daylight use. Always darken the room first in order to increase screen contrast. Never use flash as it will destroy contrast completely. Subjects such as the sciencefiction character, right, are excellent for combining with other images to create unusual effects. Remember to obtain permission first if using your camera in a cinema Pentax, 105 mm, Tri-X, 1/15, f11.

♥ Double exposure is a camera technique that you can use if you do not have the facilities for front projection. The results are less predictable but it, too, allows you to increase or reduce the apparent size of objects by making contrasts of scale. If you are using a camera without a double exposure facility, take your first image and then tighten the film in the cassette with the rewind knob. Depress the release button on the base plate of the camera to disengage the sprockets and then wind on. This should

retension the shutter without advancing the film. In the picture below, the eye was cut out of a magazine and I photographed it with a Hasselblad and a 150 mm lens. After copying this image I marked the position of the bottom of the eyelid on the camera focusing screen. To darken it a little I underexposed half a stop. Next I posed the girl against a black velvet background, then positioned the camera so she appeared below the line in the lower half of the frame and re-exposed the frame using an 80 mm lens.

Interiors

To capture the atmosphere of an interior I prefer to use existing light, with a small flash as auxiliary lighting only if absolutely necessary. Shoot from doorways or through a window to get as much space as possible and keep the light behind you whenever you can. Remember snow is an excellent natural source of extra light as it bounces light up, making dark ceilings visible.

► Fading light coming through a stained-glass window and a solitary spotlight on the organist created this atmosphere of an evening service. This was enhanced by the fact that there was little light in the rest of the church. Rolleiflex, 80 mm, Tri-X, f5.6 with tripod.

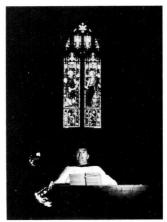

A small flash bounced off the ceiling reinforced existing light in the rather melancholy atmosphere, above. This is a good way to increase light without destroying the mood. Pentax, 55 mm, Pan-X, 1/60, f5.6. To look correct through the camera things may have to be moved. When photographing small interiors you may have to compensate by moving furniture or other objects. What appears right in reality may look wrong from the camera's single viewpoint. For formal lighting I used two electronic flashes bounced off the white ceiling. Hasselblad, 60 mm, Plus-X, 1/25, f16.

Side-lighting has brought out all the detail in the ornate temple, right. The figure of the watchful monk makes a sharp contrast with the statue and brings the picture alive. In poor light, using fast film, I was able to hand-hold the camera. Rolleiflex, 80 mm, Tri-X, 1/60, f8.

▼ Large interiors present two major problems: including enough of the subject in the picture and keeping vertical and horizontal lines parallel. To solve them you need to use a view camera with all movements or a wide-angle shift lens. The shift lens is convenient, but | prefer the view camera. Linhof, 150 mm, Plus-X, 5 sec., 132.

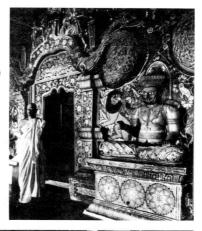

Architecture

You need to understand and appreciate different styles to photograph architecture successfully. Traditional buildings are usually best taken in a straightforward, obvious way, as the architect meant them to be seen. But remember to explore other possibilities as well: use archways and windows for framing, shoot reflections in puddles or windows, or pick a small area to represent the whole.

The four pictures of Trinity College, Cambridge, England, on this page, taken from different heights, show different aspects of the same view. Use a wide-angle lens, above, if you can't get far enough away. Today they are corrected to compensate for distortion in the vertical planes. Shift lenses are a must unless you have a view camera.

A Panoramic camera, Widelux, Plus-X, 1/250, f11.

The view of the college, left, was taken from the roof of the Gatehouse; the height provides a pleasing perspective. Try to get an unobtrusive figure in the picture to give a sense of scale.

Taken from the same height but as a horizontal composition, this view is a little easier on the eye than the more imposing composition above. Patterns made by the paths are less obtrusive but serve the same purpose of leading the eye to the main subject of the picture.

From ground level, although the paths dominate the composition, the buildings look more substantial. The lower view, because it is the one most commonly seen, is more intimate and more involved. By the angle and shape you choose you can make different areas more significant. Here the path is prominent ; the vertical lines take the eye into the picture and the horizontal ones draw the eye across. (All pictures) Pentax, 15 mm, Plus-X, 1/250, f11.

Details of old buildings can reveal superb craftsmanship ; don't overlook them. I used a red filter to bring out the grain in the wood of the door panel, right. The direction of the light has emphasized the modeling. Use long lenses for high, inaccessible places - a 100mm or even a 200mm is useful. If possible use a tripod so you don't have to worry about movement. Vivitar 35EF automatic, Plus-X. Capture the flavor of a whole building simply by photographing a detail. The section of the timbered building, below, reveals a lot about the architecture while it forms a segment of pattern

and an interesting composition. Hasselblad, 60 mm, Plus-X,

12 sec., f16.

Architecture

Modern architecture is characterized by its stark simplicity, its use of line and space and lack of ornamental detail; consequently it is very effective to photograph modern buildings in a graphic way. Look for road signs and other examples of contemporary design to emphasize this quality and, where you are photographing a building with a lot of glass, wait for light to give interesting effects.

◆ To attract the eye and lead it to the tower l included the lines on the ground in the composition, left. I used a shift lens, which means you can raise the viewpoint and the verticals are corrected; it will give a slight fall-off at the top of the picture this is usually sky, which will be darkened slightly. Pentax, 28 mm shift lens, Agfachrome 50S, 1/250, 18.

▼ Side-light on the modern library has given it the appearance of a silhouette, showing the strength and solidity of this predominantly glass building. The figures lend a sense of scale and a touch of humanity. *Rollei*, *80 mm*, 1/250, *f8*.

▶ By framing a building, as in the picture of Sydney Opera House, right, taken behind a breakwater, you get a sense of distance and you also link the building with the foreground : this is a useful professional trick which often produces a more interesting and unusual picture. Look out for conveniently situated arches, doorways or windows—or shoot through an old film box. Vivitar 35EF, automatic.

► To bring out relief in this detail of the cathedral in Liverpool I used strong sidelighting; to give greater contrast I underexposed one stop. Notice also the quality of the detail in the stonework. Although it is a good idea to include figures to give scale make sure they look fairly anonymous and do not dominate the picture. If you want to remove figures, provided they are moving and not in strong light, use slow film and a long exposure. Pentax, 28 mm, 1/250, f16.

The darkroom/Layout and equipment

For home processing and printing you do not need a permanent darkroom. A bathroom makes an ideal temporary darkroom as water is readily available. Other essential requirements are access to a power supply to run the enlarger and safelights, the ability to make the room light-tight to avoid fogging light-sensitive film and papers and, finally, some form of ventilation. For ease of use and to avoid splashing negatives and paper with chemicals, your darkroom should be divided into two areas—a dry bench and a wet bench.

The dry bench area of your darkroom should include, as a minimum, an enlarger and lens, print easel, focusing magnifier and an accurate second timer. Even if your budget is limited it is best not to skimp on the enlarger lens. There is little point in spending a lot of money on a camera lens if your enlarger lens is not capable of producing a satisfactorily sharp photograph. Dodgers and burners (see p. 115) can be made for virtually no expense and allow you control over selected areas of a print. Print trimmers, print dryers, spare negative carriers, a small desk light box for examining slides and negatives and a selection of different surfaces and grades of printing papers can all be added as your technique becomes more sophisticated.

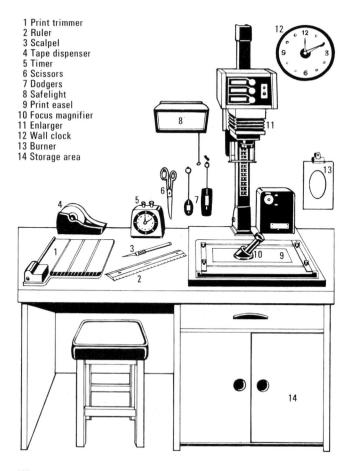

The wet bench area of your darkroom should include all the equipment and accessories you will need for processes involving water or chemicals. It is worth remembering that a lot of the time you will be working in total darkness, if processing films or printing with paper designed for color photography, or in a dim orange or red light, if using paper for black and white photography, so it is best to adopt a very methodical approach to darkroom layout. Many rolls of film and prints will be saved if bottles of dilute chemicals, trays, timers and print tongs are always placed in the same position on shelves or on the work surfaces and conveniently at hand.

Print processing trays should be laid out in the order they are needed—developing tray, stop bath and fixer. If water is available in the darkroom the fixer tray is best positioned next to the water supply. Two different types of print washer are available—a high-capacity vertical washer and a low-capacity, cheaper horizontal washer. Use different colored print tongs for each chemical process. This ensures that there will be no chemical residue carried through to the next tray to cause contamination and a shorter working capacity. To save chemicals always match tray size to paper size.

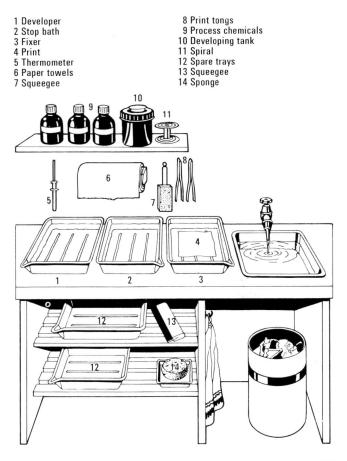

Developing black and white film

Black and white film can be processed at home in a very basic darkroom; a blacked-out bathroom or toilet will do nicely. Read the accompanying manufacturer's instructions carefully with regard to dilution, time and temperature of the process chemicals. Although some chemicals can be used more than once do not try to save money by using them more than the recommended times. Mark the bottles to indicate the number of times used. Equipment list Measuring jug Developing tank Spiral Clips Processing chemicals Thermometer Eye-dropper Scissors Timer Warming bath

After ensuring the process chemicals are at the correct temperatures (1), remove the film from its cartridge or cassette in total darkness as film is panchromatic (sensitive to light of all colors). Before loading the film into the spiral of your. developing tank, cut the end of the tapered leader square (2). Developing tanks are available in plastic or stainless steel-the latter costs more but will last a lifetime. Development commences as soon as the chemical comes in contact with the emulsion, so try and pour the developer in quickly (3). At the end of each cycle ensure the chemical is drained quickly as well because chemical reaction continues until the tank is empty of solution. Once the film is completely covered by solution it will need to be agitated to ensure all the emulsion is in constant contact with fresh solution (4). When the stop and fixing processes are complete (5 and 6) a wetting agent can be introduced to the tank after the film is washed. This wetting agent allows the film to dry evenly, thus removing drying marks on the emulsion. The most efficient washing technique is accomplished by inserting a rubber tube into the center of the tank top and turning on the tap. Water filters are available to remove the tiny particles of grit from tap water that might damage the emulsion (7). After a thorough wash the film can be hung in a dust-free environment until dry or placed in a heated film-drying cabinet (8).

Reversal film often needs to be re-exposed to light before the color developer stage. The partially processed film must be removed from the spiral and evenly exposed on both sides approximately 30 cm (2 ft) from a Number 2 photoflood bulb.

After all processing is complete and the film is dry, cut negatives into conveniently sized strips (not single negatives) and store them in specially designed acid-free paper sleeves. Slides can, of course, be cut into single frames, mounted and stored. (For details on storing negatives and slides, see pp. 26-7.)

1 Bring all chemicals to the correct temperature, 20°C (68°F), by standing them in a dish of warm water. As the temperature drops, top up with hot water.

3 Place loaded spiral in tank and pour in the developer quickly. Rap the tank on the bench to disperse any air bubbles and start timer immediately.

5 After removing all the developer pour in the stop bath until it overflows. Agitate the tank continuously for 10-15 seconds to neutralize any remaining developer.

7 Insert a rubber hose down into the center of the tank and allow a fast flow of water to wash through the film for 30 minutes. Use a filter to remove grit.

2 Remove the film from the cassette, cut the leader square and load it on to the spiral, making sure it loads evenly to prevent the film buckling.

4 To ensure even flow of fresh solution agitate the tank for 10 seconds in each minute of recommended development. Rap tank on bench to remove air bubbles.

6 Discard the stop bath and pour in the fixer. Fixation takes from 5 to 10 minutes and the tank needs to be agitated for 10 seconds out of every minute.

8 Hang film up to dry and attach a film clip to the bottom to prevent curling. Remove excess water by gently drawing a sponge down the film's length.

Making black and white contact prints

Contact printing your black and white films is the most economical method of deciding which negatives should be enlarged. A whole film of 36 negatives can be printed on one sheet of 20 x 25 cm (8 x 10 in) paper—producing an image size exactly the same as the negative's. Slight variations of contrast, exposure, composition and subject matter, which are not apparent when you look at the negatives, can easily be seen on the contact sheet. Once made, the contact sheet can be filed with your negatives to form a permanent record of your work. Equipment list Contact printer Enlarger and lens Printing paper Process chemicals (developer, stop and fix) Developing trays (3) Thermometer Second timer Print tongs (2 sets) Cleaning cloth Cleaning fluid Blower brush Print washer

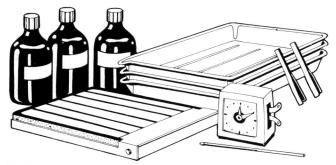

For best results, a methodical approach to darkroom work is essential. At all stages of preparation—mixing chemicals, selecting aperture and paper grade and length of exposure make a note of any factors that might need to be duplicated at a later stage.

The first step in making a contact sheet is to mix the process chemicals—developer, stop and fix—and bring them to the correct temperature (1). This will vary between manufacturers, but should be about 20°C (68°F). Purpose-built contact printers are the easiest to use, but any flat, clean surface and a sheet of glass will do. If using 35 mm film, cut it into strips consisting of six negatives. For a 36-exposure film this will give you six strips—just the right number for 20×25 cm (8 x 10 in) paper. Open the glass lid of the contact printer and, using a lint-free cloth and cleaning fluid, remove all grease marks and dust. Using a blower brush, clean the negatives thoroughly. Load each strip of negatives into the special slots on the glass. Ensure that the negatives are loaded emulsion-side down and that the frame numbers are not obscured by the slots (2). Once all the strips have been loaded, turn the room lights off and position a piece of printing paper, emulsion-side up, on the base of the contact printer (3). Bring the glass lid of the contact printer (holding the negatives) down firmly in contact with the printing paper on the base. Place the sandwich on the base board of your enlarger and expose the paper (4). You could use any white light but the enlarger lamp is probably the most convenient as it is guaranteed to give the paper an even illumination. Gauging the exposure is a matter of experience, and will vary depending on the density of the negatives and the aperture of the enlarger lens, but try 10-15 seconds at f8 for a general exposure. Remove the paper and process in the normal manner (5, 6, 7 and 8).

1 Bring the developer, stop and fix to the correct temperature and pour the chemicals into the developing trays.

3 Place the printing paper on the base board of the contract printer. Ensure it is emulsion-side up.

2 Cut the negatives into strips of six and slot them, emulsion-side down, into the glass lid of the contact printer.

4 Bring the negatives and printing paper into contact, place the contact printer on the enlarger base board and expose.

5 Tip the developer tray forward, place paper in the tray and lay it down to allow developer to wash back over paper.

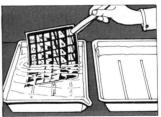

6 Allow excess developer to drain back into tray before transferring paper into the stop bath.

7 Using a different set of print tongs to avoid contamination of chemicals, transfer the print into the fixer.

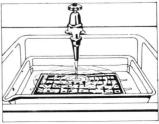

8 When fixing is complete, wash the print thoroughly in a fast-moving supply of fresh water.

Making enlargements and print control

For the photographer working in black and white attention to detail is as important in the darkroom as it is with the camera.

The process of selection and control exercised when you decide what to photograph and how to photograph it can be given a further dimension once inside the darkroom. Having made a contact print (see pp. 112-13) and chosen the negatives you wish to enlarge, selective printing can commence.

Choose chemicals and contrast grades of paper carefully as they can be used to manipulate the purity of your whites or the densities of your blacks. Paper surface can also be used as a means of disguising an overly grainy negative or diffusing an overly sharp image. Moving the enlarger head higher up the column allows you to select which part of the original negative to record. Excessively contrasted negatives can be selectively exposed so as to hold back the blacks to stop shadow detail blocking up or to give highlights additional exposure to bring out detail that would otherwise be lost.

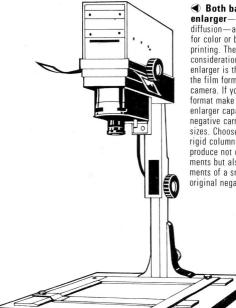

Both basic types of enlarger-condenser and diffusion—are generally suitable for color or black and white printing. The most important consideration when purchasing an enlarger is that it is suitable for the film format you use in the camera. If you use more than one format make sure you purchase an enlarger capable of accepting negative carriers of the different sizes. Choose one with a long. rigid column as this allows you to produce not only giant enlargements but also selective enlargements of a small part of the original negative.

Black and white printing allows you a choice of contrast grades varying from 0 (very soft) to 6 (very hard). Negatives lacking in contrast might benefit from being printed on grades 3, 4 or 5, whereas a high-contrast negative might be better printed on grades 0, 1 or 2. Grade 6 will eliminate nearly all shades of gray.

Unce you have decided which negative to print, inspect it carefully for drying marks, abrasions or dust. Dust can be removed using a blower brush or anti-static cloth or gun. Drying marks may necessitate rewashing and drying the film, prints made from scratched negatives will need retouching. Equipment list

Process chemicals Printing paper Enlarger and lens Blower brush Anti-static gun or cloth Print easel Timer Different sized dodgers Rigid wire Black tape Different sized burners Making a test strip allows you to look at three controlled exposures on the same sheet of printing paper and to assess which is best suited to the print. Place the negative in the negative carrier and project the image on to the print easel. Judge which part of the image contains the most representative tones, turn the enlarger off and place the test strip across that area. Next, turn on the enlarger and give the whole strip 10 seconds exposure. After this initial exposure, shield one-third of the strip with a piece of card and continue the exposure for another 10 seconds. Then position the card so that it covers two-thirds of the strip and give it a further 10 seconds.

Clean off fingerprints or dust

before loading the negative into the carrier. Inspect the enlarger lens as well. Then, with the room lights off, project the negative on to the print easel with the lens aperture wide open, adjust the height of the enlarger head to control the degree of enlargement and focus the image. Turn off the enlarger, place a sheet of printing paper in the easel and close the aperture down to the *f*-stop used to make the test strip (*r*8 or *f*11 is best). As you turn on the enlarger again, start the timer and expose the paper for the length of time indicated by the test strip.

Dodging is a darkroom technique used to hold light away from selected areas of the print which might otherwise print too dark. A dodger can be made from any piece of non-reflective, preferably black, card. Shape the dodger to approximately the size of the area you want to mask and attach it to a long piece of rigid wire. To stop the wire from reflecting unwanted light on to the print, cover it with black insulating tape. When using the dodger, keep it continually on the move, otherwise a clearly defined area of lighter tone will be evident. More than one dodger can be used to cover different areas of the print.

Burning-in is the opposite of dodging. Take a piece of non-reflecting card large enough to cover the printing paper being used. Into this card cut an aperture (or apertures) corresponding to the areas (probably highlights) of the print you want to receive more exposure. When most of the print has received sufficient exposure, cover the print with the card, allowing only the selected areas of the print to receive additional light. This technique can be extended to allow you to print vignettes around the edges of your prints. Keep the card moving to soften the lines round the area being burnt in.

Constant of

Developing color film

Slide film is probably the most immediately satisfying to process, since the slides can be put into mounts and projected as soon as they are dry. Color processing is more involved than black and white processing as it uses more individual chemical bath steps, and accurate maintenance of the high solution temperatures is of utmost importance. The chemicals will vary depending on the film to be developed. Besides the chemicals, you will need a measuring jug, beaker and storage bottle for each solution, each of which should be clearly marked and not contaminated with any other solution thereafter. You will also need a very good color-processing thermometer, preferably scaled in increments of 0.25°C. Some colorprocessing chemicals can be harmful if used without caution; wear a protective apron and rubber gloves. A single film may be developed in an enclosed tank, but two or more may be more easily developed in total darkness using a tall open-topped tank and the dunking method. This requires a processing timer with a luminous dial which can be used in the dark.

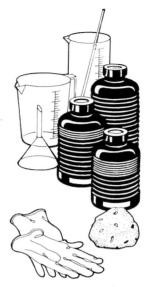

Aids for mixing workingstrength solutions from the concentrate are simply the measuring beakers and a stirring stick. Be careful not to splash any of the solutions on your clothing.

Color negative films

Virtually all color negative films can be home processed, but the most common process is called C-41. Processing is not complicated and results are good providing you follow the manufacturer's directions carefully. The seven commonly found steps, their times and temperatures are: color developer, 37.8°C; bleach, $6\frac{1}{2}$ min, 24°C; wash, $3\frac{1}{4}$ min, 38°C; fix, $6\frac{1}{2}$ min, 24°C; wash, $3\frac{1}{4}$ min, 38°C; stabilize, $1\frac{1}{2}$ min, 24°C; and dry (time and temperature variable).

Color slide films

Most color slide films can be easily home processed, but nonsubstantive films such as Kodachrome cannot since the dye couplers responsible for the final color image are in the manufacturer's process chemicals. Substantive color slide films have the dye couplers incorporated in the emulsion. Make certain you purchase the correct chemical kit for the film you are to develop (see p. 123)—they do vary. Although most processes require a high temperature, 3M and other companies now manufacture a kit that works at the usual black and white processing temperature of 20°C (68°F), which is easier to obtain and maintain. Slide films need to be fogged (re-exposed to white light) partway through processing to reverse the image from a negative to a positive one. Depending on the kit, this may also be done chemically.

Chemical activity

The factors governing chemical activity are the same as those in black and white processing—time and temperature. However, as there is less margin for error in color film processing, the times and temperatures recommended in each chemical kit must be rigidly adhered to. In addition to working accurately, you must also work quickly. The first color-developer time in the C-41 process is only $3\frac{1}{4}$ min compared to, say, 6-12 min for a black and white film. Therefore, tank draining and refilling times must be kept to the absolute minimum. This is quite easy when only one film is being developed, but if more than one is to be processed, then the dunking method is recommended. This requires a separate tank for each solution. Processing is carried out in total darkness with no lids on the tanks. At the end of each processing stage, the film is guickly pulled out of the tank, excess solution is lightly shaken off and the film is then placed in the next solution.

Essential equipment for colorfilm and print processing

Processing tank(s) and spirals Chemical-measuring beakers Chemical-storage bottles for working-strength solutions still usable for further processing

Deep trays for tank and print-tray temperature maintenance

High-temperature color thermometer marked in 0.25°C gradations

Rubber gloves and protective apron Shallow print-developing trays of

the required print size for economy of chemical solution

Squeegee for removing excess water from film before drying Weighted film-hanging clips Processing timer scaled in minutes with a sweep second hand

1 In complete darkness, remove the backing paper (roll film) or, with 35 mm, the top of the cassette using a bottle opener. Cut off the narrow film leader (35 mm) to give a square end. Load the film on to the spiral and place the loaded spiral into the tank. Place the lid on the tank. Room lights may now be turned on.

2 Mix all chemical concentrates to the correct strength. Ensure each solution is at its recommended temperature, which can be maintained by placing the beaker in a deep tray of warm water. If it is at the upper limit as processing begins, it can ''drift'' down to the lower limit while the processing cycle takes place.

3 If developing more than one or two films at the same time, use the dunking method. You will need to have each working-strength solution in a separate tank of adequate size to cover all the films being processed. Each tank should be in a deep tray bath of warm water to ensure the correct temperature is maintained.

4 At each film-washing stage the film must be immersed in a constantly changing water supply. A length of hose from the tap running into the tank will do, but the water temperature should be carefully controlled, necessitating some sort of mixing tap. To remove damaging particles, a water filter should be fitted on the tap.

Making color prints

Never before has it been so easy to make your own color prints at home. With such new products as the Agfachrome-Speed paper and activator and the Kodak Ektaflex range you can make color prints from either color negatives or color slides very simply and speedily. As clear, detailed instructions are supplied with these products, I shall here describe the traditional method of making color prints.

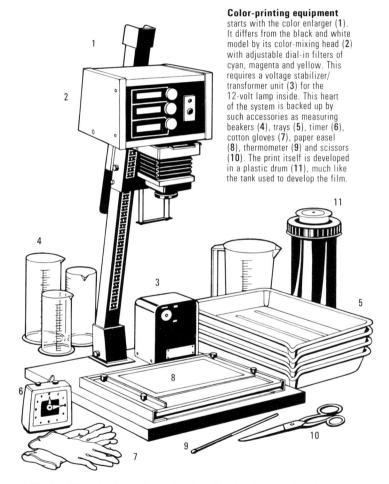

The traditional color-print and color-film developing chemicals need to be kept to very critical temperatures during each stage of the processing cycle: quite often this is to within $\pm 0.5^{\circ}$ C at a solution temperature of around 30°C (86°F). Therefore, the developing tank, film spiral and chemical beakers should be pre-heated with warm water prior to use. The tank and trays can then be immersed in a warm-water bath during processing to maintain the correct temperature. To avoid contamination each measuring jug, beaker and storage bottle should be marked, and once used for a certain chemical it should not be used for any other. Although there are some general-purpose developers on the market, color-print developing chemicals are different from film chemicals. Color prints are most often made from color negatives, distinguished by their orange mask, but prints may also be made directly from transparencies, using a reversal paper such as the (Ciba-Geigy) Cibachrome II or (Kodak) Ektachrome 14RC paper and suitable chemicals. Whichever kit you use, for best results read the accompanying instructions carefully and follow them exactly.

The first print

Before the first print can be made, a test should be carried out to determine the correct filtration (to be set on the enlarger's color filter dials) and exposure (both time and lens aperture). A color test patch will help in determining how to adjust the filters for a second test if the colors in the first were not successful. An electronic color analyser will soon pay for itself in terms of paper saved, and make color printing easier, quicker and more predictable. Once the correct filtration has been determined, it should be noted down as the starting point for all further tests for negatives or slides processed in the same chemicals and printed on the same paper.

Safelighting

Most color-printing papers need to be handled in total darkness. The darkroom must be completely blacked out until the paper has been exposed under the enlarger and placed in a print-developing drum and the lid firmly attached, making it light-tight. This is when tidiness and a methodical approach pay off. If you always arrange your items in the same order and in the same relative positions, it will be easier to locate them in the dark.

Prints from slides

Exposure characteristics are different for reversal printing papers. The more exposure you give the paper, the lighter the developed print will be. Normal filter corrections are also reversed for these papers, so note the directions carefully. Paper packs will give you suggested filtration starting points for your test print. Since the chemicals in their working strengths have a limited shelf or storage life, aim to process from six to ten prints in the same processing period. Ektachrome paper processing has eleven steps (at 30°C/86°F) and takes about 12 minutes. Cibachrome processing has four steps (at 24°C/ 75°F) and also takes 12 minutes.

The print drum

To process a single print with the minimum of solution a plastic print drum is used. After the paper has been exposed under the enlarger, it is inserted into the drum, emulsion-side inward, and the lid put on. Then with the room lights on and the chemical baths ready in their beakers at the correct temperature, processing can begin. The length of time it takes to pour in each chemical must count as part of the time allowed for each chemical process. The drum must be laid down and rolled back and forth to allow the chemical solution inside to wash back and forth over the paper. Each chemical in turn is then emptied out and replaced with the next until processing is complete. Draining time of chemicals also counts as part of the total processing time. A motorized drum base will automatically roll the drum for you, but this adds to the cost of color printing and is by no means necessary. Durst's RCP20 is a more costly machine print processor for 20 x 25 cm (8 x 10 in) prints, but you can simply insert the exposed paper in one end and eight minutes later receive the finished print (still wet) at the other end.

Film types

Films are of three main types: to produce a color negative (for a color print; sometimes called a color print film); to produce a black and white negative (for a black and white print; sometimes called a black and white print film); and to produce a transparent film positive or slide (called a color slide film, color reversal film or color transparency film).

Color film (negative or reversal) is balanced for one of two main types of light (color temperature): daylight and/or electronic flash and/or a blue flash bulb; or artificial (tungsten) light sources. Screw-on lens attachments (filters) are available to correct one type of light source for the other type of film (see p.131).

A film's sensitivity to light is expressed as its film speed rating, usually in ASA or the continental DIN numerical system. The higher the number, the more sensitive the film is to light and a correspondingly faster shutter speed or smaller aperture may be used.

Å 100 ASA film is half as sensitive as a 200 ASA film and twice as sensitive as a 50 ASA film. With the logarithmic DIN system, a difference of +3 or -3 represents a doubling or halving of film speed. In a given lighting condition, a 50 ASA film may require an exposure of *f*16, 1/60; the exposure in this situation for a 100 ASA film would be *f*16, 1/125 (or equivalent, such as *f*22, 1/60).

A size notation as 135-36 indicates a 35 mm film suitable for 36 exposures; similarly a 126-20 is a 126 film for 20 exposures. Bulk lengths are sometimes available for those who wish to economize and are willing to cut their own lengths and load them into reusable cassettes. Bulk films are available in lengths of 5 m (16.5 ft), 7.5 m (24.6 ft), 10 m (33 ft), 15 m (49 ft) or 30 m (98.5 ft).

Name	ASA speed	Sizes generally available
AGFA-GEVAERT Agfapan 25	25	135-36, 120 roll, 4 x 5 sheets
Agfapan 100	100	135-36, 120 roll, 4 x 5 sheets
Agfapan 400	400	135-36, 120 roll, 4 x 5 sheets
Agfapan Vario XL	125-1600	135-36, 120 roll
ILFORD Pan F	50	135-20, 135-36, bulk lengths, 120 roll
FP4	125	135-20, 135-36, bulk lengths, 120 and 220 rolls
HP5	400	135-20, 135-36, bulk lengths
XP1	125-1600	135-20, 135-36, bulk lengths, 120 roll
KODAK Panatomic-X	32	135-36, bulk lengths
Plus-X Pan	125	135-20, 135-36, bulk lengths
Royal-X Pan	1250	120 roll
Tri-X Pan	400	135-20, 135-36, bulk lengths, 120 roll
Verichrome Pan	125	110-12, 126-12, 126-20, 120 roll

Black and white negative films

Color negative films

Nearly all color negative film is balanced for use in daylight. However, one or two professional films are now available for use in tungsten light.

Name	ASA speed	Sizes generally available
AGFA-GEVAERT Agfacolor 100	100	110-12, 110-24, 126-12, 126-24, 135-12, 135-24, 135-36, 120 roll
Agfacolor CNS400	400	110-24, 135-24, 135-36, bulk lengths
*Agfacolor N80L	80	120 roll, sheet film
FUJI Fujicolor HR100	100	110-12, 110-24, 126-12, 126-24, CD Disc 15, 135-12, 135-24, 135-36, 120 roll
Fujicolor HR400	400	110-24, 135-24, 135-36, 120 roll
ILFORD Ilfocolor 100	100	110-24, 135-24, 135-36
llfocolor 400	400	135-24, 135-36
KODAK Kodacolor VR100	100	135-12, 135-24, 135-36
Kodacolor VR200	200	135-12, 135-24, 135-36
Kodacolor VR400	400	135-12, 135-24, 135-36
Kodacolor VR1000	1000	135-12, 135-24
SAKURA Sakuracolor II *For use in tungsta	100 en light	

Instant picture films

Instant picture film is a boon both for the casual photographer and the professional. Any error in exposure, composition or lighting can be seen immediately and another picture taken.

Name	ASA speed	Image	Exposure
KODAK Kodak PR 144	150	Color print	10
Kodamatic HS 144	320	Color print	10
POLAROID *Polaroid Type 665	75	b & w print — neg	8
*Polaroid Type 667	3000	b & w print	8
*Polaroid Type 668	80	Color print	8
Polaroid SX70 Type 778	150	Color print	10
Polaroid Type 779 * <i>Can be used in cameras from</i>	640 Nother manufa	Color print acturers	10

Color slide film

Color slide, or reversal, film requires much more careful exposure than does either black and white or color negative film, as there is no printing stage where highlights can be burnt in or shadows held back. Modern reversal emulsions do allow a little latitude in exposure—perhaps ½ to 1 *f* stop either side of the correct exposure—but when using slide film it is usually advisable to take a light reading from a highlight and allow the shadows to go a little dark. Underexposing by about ½ a stop should produce good saturated colors so bracket your exposures if you are feeling at all uncertain, particularly when gradations of tone play an important role in the image.

Name	ASA speed	Sizes generally available
AGFA-GEVAERT Agfacolor CT18	50	126-20, 135-20, 135-36 120 roll
Agfacolor CT21	100	135-36
Agfachrome 200	200	135-36
Agfachrome R100S	100	120 roll and sheet film in various sizes
FUJI Fujichrome RD	100	135-20, 135-36
Fujichrome RH	400	135-20, 135-36
ILFORD Ilfochrome 100	100	135-20, 135-36
KODAK Kodachrome 25	25	135-20, 135-36
Kodachrome 64	64	110-20, 126-20, 135-20, 136-36
Ektachrome 64	64	110-20, 126-20, 127, 135-20, 135-36, 120 roll
Ektachrome 200	200	135-20, 135-36, bulk lengths, 120 and 220 roll
Ektachrome 400	400	135-20, 135-36, bulk lengths, 120 roll
*Ektachrome 160	160	135-20, 135-36, bulk lengths, 120 roll
Ektachrome Infrared		135-36
SAKURA Sakurachrome R100	100	135-20, 135-36, bulk lengths
*For use in tungsten	light	

Black and white reversal film

The process of reversing a black and white negative film to produce slides tends to result in weak blacks and muddy whites, so it is best to buy a black and white reversal film.

Name	ASA speed	Sizes generally available
AGFA-GEVAERT Agfa Dia-Direct	32	135-36

Common color kits for home processing

For color slide films:	Agfachrome Process 41 for Agfachrome 50S and 50L film. Agfachrome Process 44 for Agfachrome R100S. Kodak E6 for processing Kodak's Ektachrome 64, Ektachrome 200 and Ektachrome 160 (Type B), plus other E6 film. Paterson Acuchrome 6 for all E6 film.
For color negative films:	Agfacolor Process II for Agfacolor 80S film. Agfacolor Process C-41 for Agfacolor 100, N80L and N100S film. Kodak Flexicolor C-41 for Kodacolor II, Vericolor II, Fujicolor II, Sakuracolor II and all other C-41 film. Paterson Acucolor Universal for Kodacolor II, Vericolor II, Fujicolor II, Sakuracolor II, Agfacolor 100, Agfacolor N100S, Agfavario XL, Ilford XPI and all other C-41 film.
For color prints from negatives:	Agfa Process 85 for Agfacolor MCN/4/PE paper. Agfa Process 92 for Agfacolor Type 6 paper. Kodak Ektaflex System with Kodak Ektaflex PCT Negative film. Kodak Ektaprint 2 for Ektacolor 78 paper.

Paterson Acucolor Universal for Kodak Ektacolor 37RC paper.

Agfachrome-Speed Activator with Agfachrome-Speed paper. Cibachrome II for Cibachrome II Kodak Ektaflex System with Kodak Ektaflex PCT Reversal film. Kodak Ektaprint R14 for Ektachrome.

Chemical Functions

For color prints from

slides:

First developer	converts the exposed silver halides (latent image) into black metallic silver
Stop bath	a solution used to stop development
Color developer	converts exposed silver halides to black metallic silver; also produces dye "cloud" around each crystal
Conditioner	prepares metallic silver for bleaching
Bleach and fix	converts metallic silver to a halide similar to the thiosulphate solutions used in b and w processes; reduces silver halides to water-soluble salts
Stabilizer	mild acid used to harden the emulsion

Filters for color photography

Filters designed specifically for color photography generally provide very slight color changes. Correction filters, though, allow film balanced for daylight to be exposed by artificial light, or artificial light film to be exposed by daylight sources.

Even when the type of film in your camera matches the light source used to illuminate the subject, a change in the quality of light may be desired. Often, pictures taken by the sea, or some other large expanse of water, exhibit dull, washed-out colors, and an overall color cast toward blue. This is usually caused by an excess of ultraviolet light in the atmosphere and can be corrected by using a UV filter over the camera lens. A skylight filter has much the same effect, but its very slight orange color adds a little warmth to shadow areas and is very useful for making pictures taken on an overcast day appear quite sunny. Polarizing filters, although expensive, are invaluable for darkening a light blue sky and strengthening the contrast between sky and clouds.

Remember that nearly all filters, with the exception of the UV and skylight filters, reduce the amount of light reaching the film and will cause underexposure unless allowed for. To compensate, additional exposure must be given. TTL metering cameras should automatically compensate for any light loss, but non-TTL cameras must be adjusted by referring to the filter factor found on the filter mount (see p. 125).

Filters for color photography Filter Use		
Wratten 80B (correction/conversion)	Adds the blue component in photoflood light, raising its color temperature to almost that of day- light, allowing daylight film to be used indoors with photoflood light.	
Wratten 85B (correction/conversion)	Alters the color temperature of daylight so that artificial light film may be exposed outdoors by day- light or indoors with electronic flash or blue flash bulbs.	
FL-D	Converts fluorescent light more closely to the color temperature of daylight. This allows photo- graphy with daylight film indoors by fluorescent light.	
UV (ultraviolet) or Skylight (1A)	Reduces UV rays, which would give prints or slides a slight overall blue cast, from reaching the film. This is noticeable on skin tones taken in shady areas under a blue sky. Can be left permanently on the lens for protection against dirt or scratching. Will penetrate the haze that would otherwise partially obscure a distant part of a scene.	
Polarizing	Reduces glare and reflections from shiny surfaces (glass, water or polished wood—but <i>not</i> metal). The only filter which will darken a light blue sky (not make a gray sky blue) without much affecting other colors.	

Contrast filters for black and white film

A contrast filter will effectively lighten the tone of objects the same color as the filter and render complementary colors as darker toned. As a black and white film may "see" the tones of a red letter box against a green hedge as being nearly the same, the letter box might be difficult to distinguish on a print against the background hedge. By using a green filter the foliage will appear lighter and the red letter box will, by comparison, appear darker. Conversely, a red contrast filter would effectively lighten the red letter box and darken the green background.

As a light reading taken from the sky might indicate an exposure two or three stops less than that indicated by an object at ground level, pretty or dramatic cloud effects have the annoying habit of burning out unless the contrast between clouds and sky is increased (when the picture is taken) by using a yellow, orange or red filter with black and white film or a polarizing filter with color film. A yellow filter increases contrast a little; a red filter can make fluffy white clouds look like a dark and stormy sky. The darker the sky color, the more the clouds become noticeable in the photograph.

Filter color	Tones of color rendered lighter (by comparison)	Tones of color rendered darker (by comparison)
Blue	Blue	Yellow Orange Red
Green	Green	Blue Orange Red
Yellow	Yellow Orange Red	Blue
Orange	Orange Red	Blue Green
Red	Red	Blue Green

Filters for color or black and white film

As nearly all filters prevent some light from reaching the film, an exposure allowance has to be made to prevent underexposure. The filter factor is the number of *f*-stops the lens needs to be opened to compensate for the light lost.

	Fil		
Filter type	Color or description	Daylight	Tungsten
1A	Skylight	0	0
UV-Haze	Clear	0	0
ND-3	2 × Neutral Density	1	1
ND-6	4 × Neutral Density	2	2

Filters for special effects

Most special-effects filters can be used with either black and white, color negative or color reversal film. No set guidelines can be laid down for their use, so experimentation is the keyword to success. Although there are quite a number of these filters available, their use should be limited to suitable subjects. Used with discretion they can add sparkle to an otherwise prosaic scene, but the danger always is that the pictorial content of the photograph may become lost. Some filters are available in both glass and gelatin, but the glass filters, although more expensive, are more resistant to abrasion and dust. These filters tend to be expensive so it is best to buy only one or two initially and learn their effects before buying others.

Filter	Use
Graduated color	Three types available—one color only, graduated from light to dark; one color graduating into another color; one color which darkens overall by rotating the front of the filter.
Dual color	A two-colored piece of glass in a filter mount.
Neutral density	A gray filter used merely to reuce the intensity of the light.
Soft focus	To give the whole picture a slightly fuzzy look.
Soft spot	To give the whole picture—except the subject in the middle of the frame—a slightly fuzzy look.
Close-up	Available in various diopter strengths (+1, +2, +3, +4) to allow a lens to focus on objects closer than it normally could.
Cross-screen or starburst	Used to spread rays of light emanating from a point source of light within a lens's field of view; usually available for four, six or eight points.
Split field	Effectively only half of a close-up lens; this allows distant and close-up subjects to be simultaneously in sharp focus beyond the depth of field associated with a particular lens at a given aperture.
Fog	Gives the picture an overall slight hazy or foggy appearance.
Prism	Available in many types, which can multiply the main subject image three, four, five or six times; for example, three parallel similar images of the subject or one main image surrounded by three or four repeated images of the subject.
Rainbow	Used to diffract light, producing a spectral pattern from any visible point source of light within the scene. The filter mount can be rotated allowing the filter effect to be positioned at any point around the light source.

Color temperature	(Kelvin)	and	filtration	
--------------------------	----------	-----	------------	--

Light Source	Color temperature Kelvins	Filtration with daylight balanced film	
Blue sky	20,000	85B	
	15,000	85	
Hazy sunlight	10,000 9,000	85C	
Average in shade, summer	8,000	81EF	
Overcast sky	7,000	81C	
Lightly overcast sky	6,500 6,000	81B 81A 81	
Summer sunlight	5,500	NO FILTER	85B
	5,000	82 82A	85
Early morning and late afternoon sunlight	4,500	82B 82C 80D	85C
	4,000	80C	81EF 81C
1hr after sunrise/before sunse Photoflood bulb	t 3,500 3,400 3,300	80B	81B 81A 81
Tungsten halogen lamp	3,200 3,100 3,000	80A	NO FILTER 82 82A
100 watt light bulb	2,900		82B
	2,800		82C
40 watt light bulb	2,700		80D

From elementary physics we know that "white" light is made up of all the colors in the spectrum. Photographically, a film sees daylight with a bluish tinge and artificial tungsten light with a yellowish tinge. This is why two types of color film are available—one for daylight (or electronic flash or blue flash bulbs) and another for artificial or tungsten light sources (or clear flash bulbs). They are said to be balanced for daylight or artificial light (Type B film) which relates to faithfully reproducing colors seen in bluish or yellowish light. Human eyes can adjust to this slight color change—film (on its own, unaided by lens filters) cannot.

Each light source has its own rating, called "color temperature." The more blue, the higher its color temperature; the more yellow, the lower its color temperature. Color temperature is measured in units of degrees on the Kelvin scale (0° K = -273° C). Color conversion or correction filters can be used in order to obtain correct colors in a scene taken with artificial light film illuminated by daylight or, vice versa, in a scene taken with daylight film illuminated by artificial light.

Flashgun guide number

A flashgun's guide number is the indication of its lighting power. It is a figure quoted either in feet or metres at a given film speed (usually ASA). For example, a flash unit with a guide number of 16 (m) at 100 ASA is half as strong as a flash unit with a

Flashgun guide number (continued)

guide number of 22 (m) at 100 ASA.

When you change to a film of a different speed, you will need to know the GN of your gun at the new film speed. For example, if a flashgun has a GN of about 16 (m) using 100 ASA film, it will have a GN of 22 (m) using 200 ASA film. Generally speaking, to calculate the correct lens aperture to use with flash (the shutter speed being determined by the camera manufacturer to synchronize at a particular setting), divide the flash unit's GN by the flash-to-subject distance. For this purpose, both the GN and flash-to-subject distance must be in the same measurement unit, i.e. both feet or both meters.

BCPS (beam candlepower second) output is a rating for the amount of light a particular flashgun puts out. W-S (watt-second) is the amount of energy discharged by the flashgun. One watt-second is approximately equal to 40 lumen-seconds.

	ASA FILM SPEED								
	25	50	64	80	100	160	200	BCPS	W-S
M F	6 20	9 28	10 32	11 35	12 40	16 50	18 56	300	8
M F	7 22	10 32	11 35	12 40	14 45	18 56	20 63	375	10
M F	8 25	11 35	12 40	14 45	16 50	20 63	22 70	450	12
M F	9 28	12 40	14 45	16 50	18 56	22 70	25 80	600	16
	10 32	14 45	16 50	18 56	20 63	25 80	28 90	750	20
M F	11 35	16 50	18 56	20 63	22 70	28 90	32 100	900	25
M F	12 40	18 56	20 63	22 70	25 80	32 100	35 110	1200	32
M F	14 45	20 63	22 70	25 80	28 90	35 110	40 125	1500	40
M F	16 50	22 70	25 80	28 90	32 100	40 125	45 140	1800	50
M F	18 56	25 80	28 90	32 100	35 110	.45 140	50 160	2400	64
M F	20 63	28 90	32 100	35 110	40 125	50 160	56 180	3000	80
M F	22 70	32 100	35 110	40 125	45 140	56 180	63 200	3600	100
M F	2 ^{.5} 80	35 110	40 125	45 140	50 160	63 200	70 220	4800	125
M F	28 90	40 125	45 140	50 160	56 180	70 220	80 250	6000	160
M F	32 100	45 140	50 160	56 180	63. 200	80 250	90 280	7200	200

128

Common errors

1

CAMERA CARE

Problem Developed film shows dark streaks, and prints show bright light streaks and/or rows of sprocket hole shadows.

Cause Light has reached the film before it has been exposed in the camera, or before it has been developed.

Solution Load and unload the film in a shady area, not in direct, bright sunlight. If no shade is available, simply turn your back to the sun and load or unload the film in your own shadow.

Problem Long scratches along the length of negatives or slides.

Cause These tracks are probably caused by dirty film guide rails or grit in the light-tight felt trap of the film cassette.

Solution Polish film guide rails with a lens cleaning cloth or lens tissue. Never remove film cassettes from their sealed containers until you are ready to load the camera.

2 Problem Torn sprocket holes.

Cause The rewind release button (often found on the base-plate of the camera) was not depressed.

Solution Ensure that the release button is fully depressed until the film has been rewound into the cassette.

4

Problem Pictures lack "bite" or sharp focus mixed with dull appearance, low in contrast or muddy looking.

Cause Front and/or rear element of the lens is dusty or has been smeared with a fingerprint.

Solution Prevention is better than cure, so if your camera is not in use keep the lens cap on. Always avoid touching the front or rear elements of your lenses, but if they do become greasy use a lens tissue or blower brush to clean the glass. Only if a lens is particularly dirty should you use a liquid lens cleaner as it can damage the delicate anti-flare coating on the glass. The ever-ready case, purchased with most cameras, is the best protection you can give your camera, shielding it from the worst effects of minor knocks, dust, rain and sea-spray. Film will not give of its best if kept, even for a short period, in very hot conditions. Remember that you should never leave a loaded camera on the rear parcel shelf of a car or in the glove box.

Cause Storing the camera in damp or humid conditions.

Solution Store your equipment in a cool, dry place and always include in your camera bag one or two packets of silica-gel to absorb any moisture. Renew or dry out the packets every few months to prevent them becoming saturated. If fungus does appear, the affected lenses must be stripped down and cleaned by a professional lens repairer.

FLASH PICTURES

Problem Pictures appear too light or too dark.

Cause Incorrect setting of the flashgun controls and/or not selecting the correct lens aperture for the conditions.

Solution Remember the method of deciding which aperture to use—the flashgun's guide number divided by the flash-to-subject distance equals the desired aperture. The guide number is usually printed either on the gun itself or in the handbook that accompanies it—the guide number changing depending on the ASA speed of the film used. The guide number is given as a figure either in feet or meters, so while doing the former calculation use distance measurements of the same unit. Also remember to check that the ASA speed of the film being used is set on the flashgun's controls.

Problem Only part of the picture is correctly exposed. One or both (opposing) edges are very dark.

Cause A camera fitted with a focal plane shutter was set at a shutter speed that was too fast to synchronize with electronic flash. When the flash was fired the shutter was only partially open, causing part of the frame to be unexposed.

Solution Check the camera's handbook to find the fastest shutter speed (called usually the X-sync speed) that can be used with electronic flash. This is normally 1/60 for horizontally traveling focal plane shutters and 1/125 for vertically traveling focal plane shutters.

8

Problem The picture is correctly exposed at the center of the frame but becomes progressively darker toward the edges of the frame.

Cause The angle of view of the lens is wider than the spread of light coming from the flashgun.

Solution Attach a wide-angle diffuser to the flash head or bounce the flash from a reflective surface. Remember that both these solutions will cause a fall-off in the intensity of the light and the aperture will need to be opened to compensate. Knowing how much to open up is basically trial and error, so it is best to shoot a test film, bracketing exposures. The

alternative, requiring no additional exposure compensation, is to use a lens with a narrower angle of view.

9

10

Problem People in the picture appear to have red eyes.

Cause The flash has been fired from a position too close to the lens axis. The red color is actually a reflection from blood vessels in the back of the eye.

Solution Bounce the light off the ceiling or wall (if using color film you need a white surface to avoid color cast). A larger aperture will be needed to compensate for the increased flash-to-subject distance and the light lost by absorption and scattering. Another solution is to connect the flash unit to the camera using an extension lead. Supporting the camera in one hand while holding the flash above the camera in the other will remove the flash far enough from the lens axis to avoid red-eye.

Problem Very bright white spots (hot spots) on shiny surfaces such as mirrors, windows or shiny glazed tiles in the picture area.

Cause Light has been reflected from these surfaces straight back into the camera lens.

Solution Stand at an angle to these shiny surfaces so that the flash will reflect away from the camera lens, or use a flash umbrella or white wall to diffuse the light.

Problem Although the flash controls and camera aperture are set correctly the picture is overexposed or underexposed.

Cause Flash exposure is calculated assuming a certain level of reflective surfaces. If the flash is fired too near a white or lightly colored surface too much light will be reflected back into the lens and on to the film; if near a black surface light will be absorbed.

Solution Close the lens aperture one-half to one full f stop to restrict the amount of light entering the lens; alternatively, open up one-half stop.

12

FRAMING ERRORS

Problem The tops of subjects' heads do not appear in the image area.

Cause Camera incorrectly aimed at the subject.

Solution Be careful to notice not just what the subject is doing but also ensure that all of the subject is included in the viewfinder frame. You may be too close to the subject (with a rangefinder camera) without noticing that the subject is outside the mark that indicates the area of parallax error (usually a bright-line frame within the viewfinder)

Problem Close-up pictures of faces in which the face appears to be slightly stretched.

Cause When a lens is used very close to a subject it tends to stretch the image toward the edges of the frame. This is somewhat evident with standard (normal) lenses, but even more so with wide-angle lenses. Facial features nearer the lens (nose and lips) appear larger than features farther away (forehead and ears)

Solution Do not stand so close to the subject that this effect is noticed in the viewfinder – usually $1.5-2 \text{ m} (1\frac{1}{2}-2 \text{ yd})$ with a standard lens. If you shoot a lot of full-face portraits and your camera accepts alternative lenses, a lens in the range 80 mm to 135mm is ideal, as it allows a single face to fill the frame without causing any distortion associated with a lens of lesser focal length.

14

Problem Extra or unwanted detail of the scene shows up in the picture, which you did not notice when you took the picture.

Cause Not paying sufficient attention to all the elements in the viewfinder and not concentrating sufficiently on composition.

Solution When taking a picture—landscape, portrait or any other scene—look not only at the main subject but at everything within the frame. You will begin to notice small details that you do not want to include. Shoot from a different angle to avoid including them in the image area. Watch for distracting telephone poles, dustbins, electric wires, etc., for these are such a common part of the scene that they are easy to overlook.

15

Problem The main subject in the picture is too small to be recognizable.

Cause The subject was not close enough to the camera.

Solution Use a longer focal length lens if your camera accepts alternative lenses, but if your camera is of the fixed-lens type you must adopt a position nearer the subject.

16

Problem A telephone pole has sprouted from your subject's head, or a tree branch appears to be growing from your subject's ear.

Cause Not paying sufficient attention to all the information in the viewfinder before the picture was taken.

Solution Pay attention to all of the scene as it appears in the viewfinder before you press the shutter release. Watch both the foreground and background, as most framing errors can be avoided by choosing a camera position carefully.

OTHER ERRORS

Problem Picture too light or too dark because of a seemingly incorrect daylight exposure.

Cause A number of factors could account for this. 1 The correct film speed (its ASA or DIN number) was not set on the camera. 2 The sun or other bright light was in the viewfinder frame causing the camera's exposure meter to indicate an underexposure. 3 The metered exposure reading was taken from the wrong part of the scene.

Solution 1 Set the correct ASA or DIN factor on the camera's film speed dial. 2 Exclude the sun or other bright light from the viewfinder before you take an exposure reading. 3 Use the light meter to assess the correct exposure from the most important element in the scene.

Problem Pictures appear fuzzy and indistinct.

Cause Incorrect focusing.

Solution Focus carefully on the most important part of the scene. When shooting portraits, focus on the sitter's eyes or the eye closest to the camera if the sitter is not facing the camera squarely. It is very disconcerting to see a portrait if the eyes are not rendered sharply in focus, as it is the eyes that most people look at first.

19

18

17

Problem Although accurately focused, pictures still appear fuzzy and indistinct.

Cause The shutter speed was too slow for successful hand-held exposure, resulting in camera shake.

Solution Select a shutter speed suitable for the weight of the camera and lens being used. With a standard lens and camera combination a tripod, or other camera support, should be used for shutter speeds slower than about 1/60.

20

Problem Developed film is blank and unexposed.

Cause Sprocket holes in the film have not engaged with the take-up spool of the camera and the film has not been transported through the camera.

Solution When loading film into the camera ensure that the sprocket holes properly engage with the take-up spool, both top and bottom. To check if the film is winding on, look to see if the rewind crank turns when the film advance lever is operated. Also, if the film has been correctly loaded the film advance lever should feel slightly stiff when stroked.

Problem Developed film is blank or the image is partially obscured.

Cause With rangefinder or TLR cameras this is probably caused by forgetting to remove the lens cap or allowing fingers or part of the camera's everready case to stray in front of the lens. This will not be noticed in the viewfinder as it does not show the scene as taken in by the lens—only an approximation of it. This problem does not occur with SLR cameras as the viewfinder shows exactly the scene as taken in by the lens.

Solution Always check that the lens cap has been removed before the exposure is made and that fingers and the ever-ready case are well away from the camera lens.

22

Problem Buildings shot from ground level appear to taper to a point at the top of the picture (converging verticals).

Cause The camera was pointed upwards to include the top of the building. This has emphasized the perspective, which makes parallel lines appear to come together in the distance. A common example of this is railway lines converging as they recede from the viewer. The brain largely compensates for this trick of perspective, but the camera cannot make such allowances and faithfully records the apparent distortion.

Solution Either emphasize the effect dramatically so that it does not look like a mistake, or forego including the tops of buildings. Another alternative is to use a wide-angle shift lens. The shift facility on these rather specialized lenses allows part of the lens to be raised slightly and has the same effect of eliminating the tapering as that achieved by the rising front facility of a view camera.

23

Problem It is not clear what constitutes the main subject as it is lost in a confusing foreground or background.

Cause Too small an aperture was selected, resulting in too great a depth of field. The result is that the subject, foreground and background are all in sharpfocus.

Solution Choose a relatively wide aperture (and a correspondingly faster shutter speed) to yield a limited depth of field. If the main subject is the only element in the picture in sharp focus it will be given much greater emphasis. It is still important to include both foreground and background detail in order to place the subject or frame it, but it should be either rendered out of focus or made tonally different so as not to take attention away from the main point of interest. Setting is often critical to the success of a photograph, so if you are not happy about the foreground or background elements, particularly if they contain a distracting amount of detail, and your subject is movable, try to make the effort to find a more suitable setting.

24

Problem When using a telephoto converter pictures are underexposed.

Cause Converters, invaluable for the photographer who would not make sufficient use of an array of prime lenses, contain a series of glass elements that magnify a part of the image transmitted by the prime lens. But with the addition of these glass elements a certain amount of light does not reach the film, causing photographs to be underexposed unless you compensate for this effect.

Solution Follow the manufacturer's recommendations concerning the number of f stops the prime lens needs to be opened to correct exposure. TTL metering automatically adjusts for light lost if the converter accepts the prime lens's light meter coupling pin.

25

Problem A series of light hexagonal or octagonal shapes in a diagonal line across the picture.

Cause The sun or other bright light source was included in the lens's angle of view when the exposure was made. The shapes noticed are in fact a series of reflections from the lens iris. Lenses are coated to minimize this sort of flaring; the more expensive the lens the better the anti-flare coating.

Solution Unless you want to use this effect exclude the sun or source of bright light from the frame by using a lens hood on the front of the lens, or position yourself so that the source of the light does not shine directly into the camera lens.

26

27

Problem When using preset (non-FAD) lenses photographs are overexposed.

Cause FAD (fully automatic diaphragm) lenses automatically close down to the preselected f stop when the shutter release is triggered, although framing and exposure adjustments are made with the aperture fully open. Preset lenses, however, do not automatically close down, causing the exposure to be made with the lens wide open.

Solution Use the additional ring found on the lens barrel to close down the lens manually to the desired aperture before triggering the shutter release.

Problem Two images appear on the same picture.

Cause The same piece of film has been exposed twice in the camera.

Solution Most modern cameras have a doubleexposure prevention device (the shutter is tensioned for the next frame only after the film has been advanced). Make sure your camera is of this type before you start taking pictures. If using a plate camera with sheet film, mark the top of the film holder "exposed" after taking the picture. Then reverse the holder and mark the other side.

Daylight exposure guide

Film speed (ASA)	Sunny	Partly cloudy/ Hazy sun	Hazy/bright (indistinct shadows)	Dull (no shadows)	
		(+1)	(+2)	(+1)	
25	1/30, <i>f</i> 16	1/30, <i>1</i> 11	1/30, <i>f</i> 5.6	1/30, <i>f</i> 4	
	1/60, <i>f</i> 11	1/60, <i>1</i> 8	1/60, <i>f</i> 4	1/60, <i>f</i> 2.8	
	1/125, <i>f</i> 8	1/125, <i>1</i> 5.6	1/125, <i>f</i> 2.8	1/125, <i>f</i> 2	
50-64	1/60, <i>f</i> 16	1/60, <i>f</i> 11	1/60, /5.6	1/60, <i>f</i> 4	
	1/125, <i>f</i> 11	1/125, <i>f</i> 8	1/125, /4	1/125, <i>f</i> 2.8	
	1/250, <i>f</i> 8	1/250, <i>f</i> 5.6	1/250, /2.8	1/250, <i>f</i> 2	
80	1/60, <i>f</i> 16- <i>f</i> 22	1/60, <i>f</i> 11- <i>f</i> 16	1/60, <i>f</i> 5.6- <i>f</i> 8	1/60, <i>f</i> 4- <i>f</i> 5.6	
	1/125, <i>f</i> 11- <i>f</i> 16	1/125, <i>f</i> 8- <i>f</i> 11	1/125, <i>f</i> 4- <i>f</i> 5.6	1/125, <i>f</i> 2.8- <i>f</i> 4	
	1/250, <i>f</i> 8- <i>f</i> 11	1/250, <i>f</i> 5.6- <i>f</i> 8	1/250, <i>f</i> 2.8- <i>f</i> 4	1/250, <i>f</i> 2- <i>f</i> 2.8	
100-125	1/125, <i>f</i> 16	1/125, <i>f</i> 11	1/125, <i>f</i> 5.6	1/125, <i>f</i> 4	
	1/250, <i>f</i> 11	1/250, <i>f</i> 8	1/250, <i>f</i> 4	1/250, <i>f</i> 2.8	
	1/500, <i>f</i> 8	1/500, <i>f</i> 5.6	1/500, <i>f</i> 2.8	1/500, <i>f</i> 2	
160	1/125, <i>f</i> 16- <i>f</i> 22	1/125, <i>f</i> 11- <i>f</i> 16	1/125, <i>f</i> 5.6- <i>f</i> 8	1/125, <i>f</i> 4- <i>f</i> 5.6	
	1/250, <i>f</i> 11- <i>f</i> 16	1/250, <i>f</i> 8- <i>f</i> 11	1/250, <i>f</i> 4- <i>f</i> 5.6	1/250, <i>f</i> 2.8- <i>f</i> 4	
	1/500, <i>f</i> 8- <i>f</i> 11	1/500, <i>f</i> 5.6- <i>f</i> 8	1/500, <i>f</i> 2.8- <i>f</i> 4	1/500, <i>f</i> 2- <i>f</i> 2.8	
200	1/125, <i>f</i> 16	1/250, <i>f</i> 11	1/250, <i>f</i> 5.6	1/250, <i>f</i> 4	
	1/250, <i>f</i> 11	1/500, <i>f</i> 8	1/500, <i>f</i> 4	1/500, <i>f</i> 2.8	
	1/500, <i>f</i> 8	1/1000, <i>f</i> 5.6	1/1000, <i>f</i> 2.8	1/1000, <i>f</i> 2	
400	1/250, <i>f</i> 22	1/250, <i>f</i> 16	1/250, <i>f</i> 8	1/250, <i>f</i> 5.6	
	1/500, <i>f</i> 16	1/500, <i>f</i> 11	1/500, <i>f</i> 5.6	1/500, <i>f</i> 4	
	1/1000, <i>f</i> 11	1/1000, <i>f</i> 8	1/1000, <i>f</i> 4	1/1000, <i>f</i> 2.8	

A subject in bright, reflective surroundings (on snow, on a beach) should be given the equivalent of one f stop less exposure (the next faster shutter speed or the next smaller f stop) due to the extra light that the surroundings reflect back onto the subject. Similarly, dark subjects in dark surroundings can be given the equivalent of one or two f stops more exposure. These exposures should be taken as a guide only. Due to the capability of the human eye to adjust readily to a decrease or increase in light intensity, the photographer can easily be fooled about exposures. When shooting negative films, it is better to err by overexposing rather than underexposing, as detail can always be "burnt-in" at the printing stage. Exposure on slide films is more critical-once exposed and developed there is precious little that can be done in the way of correcting any error. This is when an exposure meter (built into the camera or a separate hand-held one) is invaluable.

The general guide to an exposure in bright sun is to shoot at *f*16 at the shutter speed which is the reciprocal of the film speed (in ASA), i.e. with 125 ASA film, use *f*16 at 1/125 (or any equivalent exposure); with 400 ASA film, use *f*16 at 1/500 (or equivalent).

When talking about equivalent exposure, it is worth remembering that each full f stop increase (e.g. f11 to f8) represents a doubling of the size of the aperture, allowing twice as much light to reach the film. Moving the shutter speed dial from 1/125 to 1/250, for example, halves the length of time the light is allowed to enter the camera. From this it can be seen that f11, 1/125 is equivalent to f8, 1/250 in terms of the amount of light reaching the film.

Night exposure guide (at 100 ASA)

Subject	f stop/shutter speeds				
	f4	f5.6	f8	<i>f</i> 11	
Bonfire/fireworks	1/15	1/8	1/4	1/2	
Well-lit shop windows	1/30	1/15	1/8	1/4	
Well-lit streets	1/4	1/2	1	2	
Flood-lit monuments	1	2	4	8	
Full-moon landscape	1 min	2 min	4 min	8 min	
Well-lit store interiors	1/15	1/8	1/4	1/2	
Well-lit stage	1/30	1/15	1/8	1/4	
Average home lighting (close to subject)	1/4	1/2	1	2	

Shoot night scenes, if possible, before the sky goes completely black. Dusk is best, as there is still enough available light to fill in detail and provide some modeling; the above exposure times may then be halved. Remember that many such "night" scenes will not benefit from the relatively small amount of light from an ordinary amateur flashgun. Bonfire and fireworks pictures, for example, *cannot* be taken with flash as the flash will kill the atmosphere and effects you are trying to capture on film. The resulting long exposures require the use of a tripod or other camera-steadying device and a cable release to avoid camera shake and blurred pictures.

Stage performers and sportsmen do not welcome flash being used during their performances. In many cases flash will not ensure a good exposure anyway and will annoy the performer and audience. It is often prohibited, so always check with the organizers first.

By using a wider lens aperture and a faster film (e.g. 400 ASA) you can sometimes reduce exposure time so that you do not need a tripod and cable release. These exposures should be taken only as a guide. Bracketing will probably be necessary to ensure a good exposure; take a second picture giving it half the recommended exposure and a third giving it twice the exposure.

If, during an exposure of longer than about 4 sec, a moving subject (pedestrian, car, etc.) travels across the picture area, simply cover the lens with your hand or a piece of card until the interference has passed; then remove the cover to continue the remainder of the exposure, adding on the time the lens was covered.

With exposures longer than about 1 sec, the reciprocity factor should be considered. This means that in a given situation, closing the lens aperture by one stop does not necessarily call for twice the exposure time, but probably a bit more. It is safer to add a few extra seconds exposure time for shots which call for several seconds initially, and to bracket exposure around this assumed exposure time if possible. The reciprocity factor will also affect the color balance of color film.

Working with black and white film also allows you the option of uprating, or pushing, your film. For example, 400 ASA film can be exposed as if it were 800 ASA Adjustments can be made at the development stage to compensate for this one-stop underexposure, and acceptable, if grainy, pictures will result.

Glossary

Words in CAPITAL LETTERS cross-refer to other entries in the glossary

Aberration. Inherent fault in a lens image. Aberrations include ASTIGMATISM, BARREL DISTORTION, CHROMATIC ABERRATION. COMA, PINCUSHION DISTORTION, SPHERICAL ABERRATION. COMPOUND LENSES minimize aberrations.

Accelerator. Alkali in a developer, used to speed up its action.

Actinic. (Describing light) able to affect photographic material. With ordinary film, visible light and some ultraviolet light is actinic, while infra-red is not.

Aerial perspective. Sense of depth in a scene caused by haze. Distant objects appear in gentler tones than those in the foreground and they tend to look bluish. The eye interprets these features as indicating distance.

Air bells. Bubbles of air clinging to the emulsion surface during processing, which prevent uniform chemical action. Removed by agitation.

Airbrush. An instrument used by photographers for retouching prints. It uses a controlled flow of compressed air to spray paint or dye.

Anamorphic lens. Special type of lens which compresses the image in one dimension by means of cylindrical or prismatic elements. The image can be restored to normal by using a similar lens for printing or projection.

Angle of view. Strictly the angle subtended by the diagonal of the film at the rear NODAL POINT of the lens. Generally taken to mean the wider angle "seen" by a given lens. The longer the focal length of a lens, the narrower its angle of view. See also COVERING POWER.

Aperture. Strictly, the opening that limits the amount of light reaching the film and hence the brightness of the image. In some cameras the aperture is of a fixed size; in others it is in the form of an opening in a barrier called the DIAPHRAGM and can be varied in size. (An *iris* diaphragm forms a continuously variable opening, while a stop plate has a number of holes of varying sizes.) Photographers, however, generally use the term ''aperture'' to refer to the diameter of this opening. See also F-NUMBER.

ASA. American Standards Association, which devised one of the two most

commonly used systems for rating the speed of an emulsion (i.e., its sensitivity). A film rated at 400 ASA would be twice as fast as one rated at 200 ASA and four times as fast as one rated at 100 ASA. See also DIN and BSI.

Astigmatism. The inability of a lens to focus vertical and horizontal lines in the same focal plane. Corrected lenses are called ''anastigmatic''

Automatic camera. Camera in which the exposure is automatically selected. A semi-automatic camera requires the user to pre-select the shutter speed or the aperture.

Back projection. Projection of slides on to a translucent screen from behind, instead of on to the front of, a reflective screen.

Ball-and-socket head. A type of tripod fitting that allows the camera to be secured at the required angle by fastening a single locking-screw. See also PAN-AND-TILT HEAD.

Barn doors. Hinged flaps for studio lamps, used to control the beam of light.

Barrel distortion. Lens defect characterized by the distortion of straight lines at the edges of an image so that they curve inward at the corners of the frame.

Bas relief. In photography the name given to the special effect created when a negative and positive are sandwiched together and printed slightly out of register. The resulting picture gives the impression of being carved in low relief, like a bas-relief sculpture.

Beaded screen. Type of front-projection screen. The surface of the screen is covered with minute glass beads, giving a brighter picture than a plain white screen.

Bellows. Light-tight folding bag made of pleated cloth used on some cameras to join the lens to the camera body.

Between-the-lens shutter. One of the two main types of shutter. Situated close to the diaphragm, it consists of thin metal blades or leaves which spring open and then close when the camera is fired, exposing the film. See also FOCAL PLANE SHUTTER.

Bleaching. Chemical process for removing black metallic silver from the

emulsion by converting it to a compound that may be dissolved.

Bloom. Thin coating of metallic fluoride on the air-glass surface of a lens. It reduces reflections at that surface.

Bounced flash. Soft light achieved by aiming flash at a wall or ceiling to avoid the harsh shadows that result if the light is pointed directly at the subject.

Bracketing. Technique of ensuring perfect exposure by taking several photographs of the same subject at slightly different settings.

Bromide paper. Photographic paper for printing enlargements. The basic light-sensitive ingredient in the emulsion is silver bromide.

B setting. Setting of the shutter speed dial of a camera at which the shutter remains open for as long as the release button is held down, allowing longer exposures than the preset speeds on the camera. The ''B'' stands for ''brief'' or ''bulb'' (for historical reasons). See also I SETING.

BSI. British Standards Institution, which has an independent system of rating emulsion speed, similar to the ASA system. However, the BSI system is used industrially rather than by photographers.

Bulk loader. Device for handling film which has been bought in bulk as a single length and which needs to be cut and loaded into cassettes.

Burning in. Technique used in printing photographs when a small area of the print requires more exposure than the rest. After normal exposure the main area is shielded with a card or by the hands while the detail (e.g., a highlight which is too dense on the negative) receives further exposure. See also DODGING.

Cable release. Simple camera accessory used to reduce camera vibrations when the shutter is released, particularly when the camera is supported by a tripod and a relatively long exposure is being used. It consists of a short length of thin cable attached at one end to the release button of the camera; the cable is encased in a flexible rubber or metal tube and is operated by a plunger. **Callier effect.** Phenomenon which accounts for the higher contrast produced by enlargers using a condenser system as compared with those using a diffuser system. This effect, first investigated by André Callier in 1909, is explained by the fact that the light, focused by the condenser on to the lens of the enlarger, is partly scattered by the negative before it reaches the lens; and because the denser parts of the negative scatter the most light, the contrast is increased. In a diffuser enlarger, on the other hand, all areas of the negative cause the same amount of scattering.

Calotype. Print made by an early photographic process using paper negatives. lodized paper requiring lengthy exposure was used in the camera. The system was patented by Fox Talbot in 1841, but became obsolete with the introduction of the COLLODION PROCESS. Also known as Talbotype.

Camera movements. Adjustments to the relative positions of the lens and the film whereby the geometry of the image can be controlled. A full range of movements is a particular feature of view cameras, though a few smaller cameras allow limited movements, and special lenses are available which do the same for 35 mm cameras.

Camera obscura. Literally, a ''dark chamber''. An optical system, familiar before the advent of photographic materials, using a pinhole or a lens to project an image on to a screen. One form, of camera obscura, designed as an artists' aid, is the ancestor of the modern camera.

Canada balsam. Resin used to cement together pieces of optical glass, such as elements of a lens. When set it has a refractive index almost exactly equal to that of glass. It is obtained from the balsam fir of North America.

Cartridge. Plastic container of film, either 126 or 110. The film is wound from one spool to a second spool inside the cartridge.

Cassette. Container for 35 mm film. After exposure the film is wound back on to the spool of the cassette before the camera is opened.

Cast. Overall shift toward a particular hue, giving color photographs an unnatural appearance.

CdS cell. Photosensitive cell used in one type of light meter, incorporating a cadmium sulphide resistor, which regulates an electric current. See also SELENIUM CELL.

Glossary

Center-weighted meter. Type of through-the-lens light meter. The reading is most strongly influenced by the intensity of light at the center of the image.

Chromatic aberration. The inability of a lens to focus different colors on the same focal plane.

Circle of confusion. Disc of light in the image produced by a lens when a point on the subject is not perfectly brought into focus. The eye cannot distinguish between a very small circle of confusion (of diameter less than 0-01 in) and a true point.

Close-up lens. Simple positive lens placed over the normal lens to magnify the image. The strength of the close-up lens is measured in DIOPTERS. Also known as SUPPLEMENTARY LENS.

Cold cathode enlarger. Type of enlarger using as its light source a special fluorescent tube with a low working temperature. Particularly suitable for largeformat work.

Collodion process. Wet-plate photographic process introduced in 1851 by F. Scott Archer, remaining in use until the 1880s. It superseded the DAGUERREOTYPE and CALOTYPE processes.

Color analyzer. Electronic device which assesses the correct filtration for a color print.

Color conversion filters. Camera filters required when daylight color film is used in artificial light, or when film balanced for artificial light is used in daylight.

Color correction filters. Filters used to correct slight irregularities in specific light sources (e.g., electronic flash). The name is also used to describe the cyan, magenta and yellow filters which are used to balance the color of prints made from color neatives.

Color negative film. Film giving color negatives intended for printing.

Color reversal film. Film giving color positives (i.e., slides or transparencies) directly. Prints can also be made from the positive transparencies.

Color temperature. Measure of the relative blueness or redness of a light source, expressed in kelvins. The color temperature is the temperature to which a theoretical "black body" would have to be heated to give out light of the same color.

Coma. A lens defect which results in offaxis points of light appearing in the image not as points but as discs with comet-like tails.

Compound lens. Lens consisting of more than one element, designed so that the faults of the various elements largely cancel each other out.

Condenser. Optical system consisting of one or two plano-convex lenses (flat on one side, curved outward on the other) used in an enlarger or slide projector to concentrate light from a source and focus it onto the negative or slide.

Contact print. Print which is the same size as the negative, made by sandwiching together the negative and the photographic paper when making the print.

Converging lens. Any lens that is thicker in the middle than at the edges. The name derives from the ability of such lenses to cause parallel light to converge on to a point of focus, giving an image. Also known as a positive lens. See also DIVERGING LENS.

Converging verticals. Distorted appearance of vertical lines in the image, produced when the camera is tilted upwards: tall objects such as buildings appear to be leaning backward. Can be partially corrected at the printing stage, or by the use of CAMERA MOVEMENTS.

Converter. Auxiliary lens, usually fitted between the camera body and the principal lens, giving a combined focal length that is greater than that of the principal lens alone. Most converters increase focal length by a factor of two or three.

Convertible lens. Compound lens consisting of two lens assemblies which are used separately or together. The two sections are usually of differing focal lengths, giving three possible permutations.

Correction filter. Colored filter used over the camera lens to modify the tonal balance of a black and white image; the same term is also used for COLOR CORRECTION FILTERS.

Covering power. The largest image area of acceptable quality that a given lens produces. The covering power of a lens is normally only slightly greater than the standard negative size for which it is intended, except in the case of a lens designed for use on a camera with movements (see CAMERA MOVEMENTS), when the covering power must be considerably greater.

Cropping. Enlarging only a selected portion of the negative instead of printing the entire area.

Daguerreotype. Early photographic picture made on a copper plate coated with polished silver and sensitized with silver iodide. The image was developed using mercury vapour, giving a direct positive. The process was introduced by Louis Daguerre in 1839, and was the first to be commercially successful.

Daylight film. Color film balanced to give accurate color rendering in average daylight, that is to say, when the COLOR TEMPERATURE of the light source is around 6500 kelvins. Also suitable for use with electronic flash and blue flashbulbs.

Density. The light-absorbing power of a photographic image. A logarithmic scale is used in measurements: 50 per cent absorption is expressed as 0.3, 100 per cent is 1.0, etc. In general terms, density is simply the opaqueness of a negative or the blackness of a print.

Depth of field. Zone of acceptable sharpness extending in front of and behind the point on the subject which is exactly focused by the lens.

Depth of focus. Very narrow zone on the image side of the lens within which slight variations in the position of the film will make no appreciable difference to the focusing of the image.

Developer. Chemical agent which converts the LATENT IMAGE into a visible image.

Diaphragm. System of adjustable metal blades forming a roughly circular opening of variable diameter, used to control the APERTURE of a lens.

Diapositive. Alternative name for TRANSPARENCY.

Dichroic fog. Processing fault characterized by a stain of reddish and greenish colors—hence the name ''dichroic'' (literally, ''two-colored''). Caused by the use of exhausted FIXER whose acidity is insufficient to halt the development entirely. A fine deposit of silver is formed which appears reddish by transmitted light and greenish by reflected light. **Differential focusing.** Technique involving the use of shallow DEPTH OF FIELD to enhance the illusion of depth and solidity in a photograph.

Diffraction. Phenomenon occurring when light passes close to the edge of an opaque body or through a narrow aperture. The light is slightly deflected, setting up interference patterns which may sometimes be seen by the naked eye as fuzziness. The effect is occasionally noticeable in photography, as when, for example, a very small lens aperture is used.

DIN. Deutsche Industrie Norm, the German standards association, which devised one of the two widely used systems for rating the speed of an emulsion (see also ASA). On the DIN scale, every increase of 3 indicates that the sensitivity of the emulsion has doubled. 21 DIN is equivalent to 100 ASA.

Diverging lens. Any lens that is thicker at the edges than in the middle. Such lenses cause parallel rays of light to diverge, forming an image on the same side of the lens as the subject. Diverging lenses are also known as negative lenses.

D-max. Technical term for the maximum density of which an emulsion is capable.

Dodging. Technique, also known as shading, used in printing photographs when one area of the print requires less exposure than the rest. A hand or a sheet of card is used to prevent the selected area receiving the full exposure. See also BURNING IN.

Drift-by technique. Processing technique used to allow for the cooling of a chemical bath (normally the developer) during the time it is in contact with the emulsion. Before use, the solution is warmed to a point slightly above the required temperature, so that while it is being used it cools to a temperature slightly below, but still within the margin of safety.

Drying marks. Blemishes on the emulsion resulting from uneven drying; also, residue on the film after water from the wash has evaporated.

Dry mounting. Method of mounting prints on to card backing, using a special heat-sensitive adhesive tissue.

Dye coupler. Chemical responsible for producing the appropriate colored dyes during the development of a color photograph. Dye couplers may be incorporated in the emulsion; or they may be part of the developer.

Glossary

Electronic flash. Type of flashgun which uses the flash of light produced by a high-voltage electrical discharge between two electrodes in a gas-filled tube. See also FLASHBULB.

Emulsion. In photography, the lightsensitive layer of a photographic material. The emulsion consists essentially of SILVER HALIDE crystals suspended in GELATIN.

Enlargement. Photographic print larger than the original image on the film. See also CONTACT PRINT.

Exposure. Total amount of light allowed to reach the light-sensitive material during the formation of the LATENT IMAGE. The exposure is dependent on the brightness of the image, the camera APERTURE and on the length of time for which the photographic material is exposed.

Exposure meter. Instrument for measuring the intensity of light so as to determine the correct SHUTTER and APERTURE settings.

Extension tubes. Accessories used in close-up photography, consisting of metal tubes that can be fitted between the lens and the camera body, thus increasing the lens-to-film distance.

Farmer's reducer. Solution of potassium ferricyanide and sodium thiosulphate, used in photography to bleach negatives and prints.

Fast lens. Lens of wide maximum aperture, relative to its focal length. The current state of lens design and manufacture determines the standards by which a lens is considered "fast" for its focal length.

Fill-in. Additional lighting used to supplement the principal light source and brighten shadows.

Film speed. A film's degree of sensitivity to light. Usually expressed as a rating on either the ASA or the DIN scales.

Filter. Transparent sheet, usually of glass or gelatin, used to block a specific part of the light passing through it, or to change or distort the image in some way. See also COLOR CONVERSION FILTERS, COLOR CORRECTION FILTERS, CORRECTION FILTERS and POLARIZING FILTERS. Fisheye lens. Extreme wide-angle lens, with an ANGLE OF VIEW of about 180°. Since its DEPTH OF FIELD is almost infinite, there is no need for any focusing, but it produces images that are highly distorted.

Fixed-focus lens. Lens permanently focused at a fixed point, usually at the HYPERFOCAL DISTANCE. Most cheap cameras use this system, giving sharp pictures from about 7 ft (2 metres) to infinity.

Fixer. Chemical bath needed to fix the photographic image permanently after it has been developed. The fixer stabilizes the emulsion by converting the undeveloped SILVER HALIDES into water-soluble compounds, which can then be dissolved out.

Flare. Light reflected inside the camera or between the elements of the lens, giving rise to irregular marks on the negative and degrading the quality of the image. It is to some extent overcome by using bloomed lenses (see BLOOM).

Flashbulb. Expendable bulb with a filament of metal foil which is designed to burn up very rapidly giving a brief, intense flare of light, sufficiently bright to allow a photograph to be taken. Most flashbulbs have a light blue plastic coating, which gives the flash a COLOR TEMPERATURE close to that of daylight.

Floodlight. General term for artificial light source which provides a constant and continuous output of light, suitable for studio photography or similar work. Usually consists of a 125–500W tungsten-filament lamp mounted in a reflector.

F-number. Number resulting when the focal length of a lens is divided by the diameter of the aperture. A sequence of f-numbers, marked on the ring or dial which controls the diaphragm, is used to calibrate the aperture in regular steps (known as STOPS) between its smallest and largest settings. The f-numbers generally follow a standard sequence such that the interval between one stop and the next represents a halving or doubling in the image brightness. As f-numbers represent fractions, the numbers become progressively higher as the aperture is reduced to allow in less light.

Focal length. Distance between the optical center of a lens and the point at which rays of light parallel to the optical axis are brought to a focus. In general, the greater the focal length of a lens, the smaller its ANGLE OF VIEW.

Focal plane. Plane on which a given subject is brought to a sharp focus; plane where the film is positioned.

Focal-plane shutter. One of the two main types of shutter, used almost universally in SINGLE-LENS REFLEX CAMERAS. Positioned behind the lens (though in fact slightly in front of the focal plane) the shutter consists of a system of cloth blinds or metal blades; when the camera is fired, a slit travels across the image area either vertically or horizontally. The width and speed of travel of the slit determine the duration of the exposure.

Forced development. Technique used to increase the effective speed of a film by extending its normal development time. Also known as ''pushing'' the film.

Format. Dimensions of the image recorded on film by a given type of camera. The term may also refer to the dimensions of a print.

Fresnel lens. Lens whose surface consists of a series of concentric circular "steps", each of which is shaped like part of the surface of a convex lens. Fresnel lenses are often used in the viewing screens of single-lens reflex cameras and for spotlights.

Gelatin. Colloid material used as binding medium for the emulsion of photographic paper and film; also used in some types of filter.

Glazing. Process by which glossy prints can be given a shiny finish by being dried in contact with a hot drum or plate of chromium or steel.

Grain. Granular texture appearing to some degree in all processed photographic materials. In black and white photographs the grains are minute particles of black metallic silver which constitute the dark areas of a photograph. In color photographs the silver has been removed chemically, but tiny blotches of dye retain the appearance of graininess. The faster the film, the coarser the grain.

Granularity. Objective measure of graininess.

Guide number. Number indicating the effective power of a flash unit. For a given film speed, the guide number divided by the distance between the flash and the subject gives the appropriate F-NUMBER to use.

Halation. Phenomenon characterized by halo-like band around the developed image of a bright light source. Caused by internal reflection of light from the support of the emulsion (i.e., the paper of the print or the base laver of a film).

Half-frame. Film format measuring 24 x 18 mm, half the size of standard format 35 mm pictures.

Halogens. A particular group of chemical elements, among which chlorine, bromine and iodine are included. These elements are important in photography because their compounds with silver (SILVER HALIDES) form the light-sensitive substances in all photographic materials.

Hardener. Chemical used to strengthen the gelatin of an emulsion against physical damage.

High-key. Containing predominantly light tones. See also LOW-KEY.

Highlights. Brightest area of the subject, or corresponding areas of an image; in the negative these are areas of greatest density.

Holography. Technique whereby information is recorded on a photographic plate as an interference pattern which, when viewed under the appropriate conditions, yields a three-dimensional image. Holography bears little relation to conventional photography except in its use of a light-sensitive film.

Hot shoe. Accessory shoe on a camera which incorporates a live contact for firing a flashgun, thus eliminating the need for a separate contact.

Hue. The quality that distinguishes between colors of the same saturation and brightness; the quality, for example, of redness or greenness.

Incident light. Light falling on the subject. When a subject is being photographed, readings may be taken of the incident light instead of the reflected light.

Infra-red radiation. Part of the spectrum of electromagnetic radiation, having wavelengths longer than visible red light (approximately 700 to 15,000 nanometres). Infra-red radiation is felt as heat, and can be recorded on special types of photographic film. See IR SETLING.

Glossary

Integral tripack. Composite photographic emulsion used in virtually all color films and papers, comprising three layers, each of which is sensitized to one of the three primary colors.

Intermittency effect. Phenomenon observed when an emulsion is given a series of brief exposures. The density of the image thus produced is lower than the image density produced by a single exposure of duration equal to the total of the short exposures.

Inverse square law. Law stating that, for a point source of light, the intensity of light decreases with the square of the distance from the source; thus, when the distance is doubled, the intensity is reduced by a factor of four.

IR (infra-red) setting. A mark sometimes found on the focusing ring of a camera, indicating a shift in focus needed for infra-red photography. Infra-red radiation is refracted less than visible light, and the infra-red image is therefore brought to a focus slightly behind the visible image.

Irradiation. Internal scattering of light inside photographic emulsions during exposure, caused by reflections from the SILVER HALIDE crystals.

Joule. Unit of energy in the SI (Système International) system of units. The joule is used in photograpy to indicate the output of an electronic flash.

Kelvin (K). Unit of temperature in the SI system of units. The Kelvin scale begins at absolute zero (-273° C) and uses degrees equal in magnitude to 1° C. Kelvins are used in photography to express COLOR TEMPERATURE.

Laser. Acronym for Light Amplification by Stimulated Emission of Radiation. Device for producing an intense beam of coherent light that is of a single very pure color. Used in the production of holograms (see HOLOGRAPHY).

Latensification. Technique used to increase effective film speed by fogging the film, either chemically or with light, between exposure and development.

Latent image. Invisible image recorded on photographic emulsion as a result of exposure to light. The latent image is converted into a visible image by the action of a DEVELOPER. **Latitude.** Tolerance of photographic material to variations in exposure.

Lens hood. Simple lens accessory, usually made of rubber or light metal, used to shield the lens from light coming from areas outside the field of view. Such light is the source of FLARE.

Lith film. Ultrahigh-contrast film used to eliminate gray tones and reduce the image to areas of pure black or pure white.

Long-focus lens. Lens of focal length greater than that of the STANDARD LENS for a given format. Long-focus lenses have a narrow field of view, and consequently make distant objects appear closer. See also TELEPHOTO LENS.

Low-key. Containing predominantly dark tones. See also HIGH-KEY.

Macro lens. Strictly, a lens capable of giving a 1:1 magnification ratio (a lifesize image); the term is generally used to describe any close-focusing lens. Macro lenses can also be used at ordinary subject distances.

Macrophotography. Close-up photography in the range of magnification between life-size and about ten times life-size.

Magnification ratio. Ratio of image size to object size. The magnification ratio is sometimes useful in determining the correct exposure in close-up and macrophotography.

Mercury vapor lamp. Type of light source sometimes used in studio photography, giving a bluish light. The light is produced by passing an electric current through a tube filled with mercury vapor.

Microphotography. Technique used to copy documents and similar materials on to very small-format film, so that a large amount of information may be stored compactly. The term is sometimes also used to refer to the technique of taking photographs through a microscope, otherwise known as PHOTOMICROGRAPHY.

Microprism. Special type of focusing screen composed of a grid of tiny prisms, often incorporated into the viewing screens of SLR cameras. The microprism gives a fragmented image when the image is out of focus. Mired. Acronym for Micro-Reciprocal Degree. Unit on a scale of COLOR TEMPERATURE used to calibrate COLOR CORRECTION FILTERS. The mired value of a light is given by the express: one million + color temperature in kelvins.

Mirror lens. Long-focus lens of extremely compact design whose construction is based on a combination of lenses and curved mirrors. Light rays from the subject are reflected backwards and forwards inside the barrel of the lens before reaching the film plane. Also known as a catadioptric lens.

Montage. Composite photographic image made from several different pictures by physically assembling them or printing them successively on to a single piece of paper.

Motor drive. Battery-powered camera accessory, used to wind on the film automatically after each shot, capable of achieving several frames per second.

Negative. Image in which light tones are recorded as dark, and vice versa; in color negatives every color in the original subject is represented by its complementary color.

Negative lens. See DIVERGING LENS.

Neutral density filter. Uniformly gray filter which reduces the brightness of an image without altering its color content. Used in conjunction with lenses that have no diaphragm to control the aperture (such as MIRROR LENSES), or when the light is too bright for the speed of film used.

Newton's rings. Narrow multicolored bands that appear when two transparent surfaces are sandwiched together with imperfect contact. The pattern is caused by interference, and can be troublesome when slides or negatives are held between glass or plastic.

Nodal point. Point of intersection between the optical axis of a compound lens and one of the two principal planes of refraction: a compound lens thus has a front and a rear nodal point, from which its basic measurements (such as focal length) are made.

Normal lens. See STANDARD LENS.

Opacity. Objective measurement of the degree of opaqueness of a material: the ratio of incident light to transmitted light.

Open flash. Technique of firing flash manually after the camera shutter has been opened instead of synchronizing the two.

Optical axis. Imaginary line running through the optical center of an optical system at a right angle to the image and film plans.

Orthochromatic. Term used to describe black and white emulsions that are insensitive to red light. See also PANCHROMATIC.

Oxidation. Chemical reaction in which a substance combines with oxygen. Developer tends to deteriorate as a result of oxidation unless stored in airtight containers.

Pan-and-tilt head. Type of tripod head employing independent locking mechanisms for movement in two planes at right angles to each other. Thus the camera can be locked in one plane while remaining free to move in the other.

Panchromatic. Term used to describe black and white photographic emulsions that are sensitive to all the visible colors (although not uniformly so). Most modern films are panchromatic. See also ORTHOCHROMATIC.

Panning. Technique of swinging the camera to follow a moving subject, used to convey the impression of speed. A relatively slow shutter speed is used, so that a sharp image of the moving object is recorded against a blurred background.

Panoramic camera. Special design of camera whose lens moves slowly through an arc during exposure, covering a long stretch of film.

Parallax. Apparent displacement of an object brought about by a change in viewpoint. Parallax error is apparent in close-ups only, shown in the discrepancy between the image produced by the lens and the view seen through the viewfinder in cameras where the viewfinder and taking lens are separate.

Pentaprism. Five-sided prism used in the construction of eye-level viewfinders for SLR cameras, providing a laterally correct, upright image. (In practice many pentaprisms have more than five sides, since unnecessary parts of the prism are cut off to reduce its bulk.)

pH value. Strictly, the logarithm of the concentration of hydrogen ions in grams per litre. Used as a scale of acidity or alkalinity of a substance. Water is neutral at pH 7.

Glossary

Photo-electric cell. Light-sensitive cell used in the circuit of a light meter. Some types of photo-electric cell generate an electric current when stimulated by light; others react by a change in their electrical resistance.

Photoflood. Bright tungsten filament bulb used as an artificial light source in photography. The bulb is over-run and so has a short life.

Photogram. Photographic image produced by arranging objects on the surface of a sheet of photographic paper or film, or so that they cast a shadow directly on to the material as it is being exposed. The image is thus produced without the use of a lens.

Photometer. Instrument for measuring the intensity of light by comparing it with a standard source.

Photomicrography. Technique of taking photographs through the lens of a microscope, used to achieve magnifications greater than those obtainable using a MACR0 LENS.

Physiogram. Photographic image of the pattern traced out by a light source suspended from a pendulum. The pattern depends on the arrangement and complexity of the pendulum.

Pinhole camera. Simple camera which employs a very small hole instead of a lens to form an image. Pinhole cameras are principally used as a simple demonstration of the idea that light travels in straight lines; but they can take photographs.

Polarizing filter. Thin transparent filter used as a lens accessory to cut down reflections from certain shiny surfaces (notably glass and water) or to intensify the color of a blue sky. Polarizing filters are made of a material that will polarize light passing through it and which will also block a proportion of light that has already been polarized: rotating the filter will vary the proportion that is blocked.

Polarized light. Light whose electrical vibrations are confined to a single plane. In everyday conditions, light is usually unpolarized, having electrical (and magnetic) vibrations in every plane. Light reflected from shiny non-metallic surfaces which makes it difficult to distinguish color and detail is frequently polarized and can be controlled with a POLARIZING FILTER.

Positive. Image in which the light tones correspond to the light areas of the subject, and the dark tones correspond to the dark areas; in a positive color image, the colors of the subject are also represented by the same colors in the image. See NEGATIVE.

Positive lens. See CONVERGING LENS.

Posterization. Technique of drastically simplifying the tones of an image by making several negatives from an original, with different densities, contrasts, etc., and then sandwiching them together and printing them in register.

Primary colors. In the ADDITIVE SYNTHESIS of color, blue, green and red. Lights of these colors can be mixed together to give white light or light of any other color.

Process film. Slow, fine-grained film of good resolving power, used for copying work.

Process lens. Highly corrected lens designed specially for copying work.

Pushing. Technique of extending the development of a film so as to increase its effective speed or to improve contrast.

Rangefinder. Optical device for measuring distance, often coupled to the focusing mechanism of a camera lens. A rangefinder displays two images, showing the scene from slightly different viewpoints, which must be superimposed to establish the measurement of distance.

Real image. In optics, the term used to describe an image that can be formed on a screen, as distinct from a VIRTUAL IMAGE. The rays of light actually pass through the image before entering the eye of the observer.

Reciprocity law. Principle according to which the density of the image formed when an emulsion is developed is directly proportional to the duration of the exposure and the intensity of the light. However, with extremely short or long exposures and with unusual light intensities the reciprocity law fails to apply and unpredictable results occur. See also INTERMITENCY EFFECT.

Reducer. Chemical agent used to reduce the density of a developed image either uniformly over the whole surface (leaving the contrast unaltered) or in proportion to the existing density (thus decreasing contrast). **Reflector.** In photography, the sheets of white, gray or silverized card employed to reflect light into shadow areas, usually in studio lighting arrangements.

Reflex camera. Generic name for types of camera whose viewing systems employ a mirror to reflect an image on to a screen. See TWIN-LENS REFLEX CAMERA and SINGLE-LENS REFLEX CAMERA.

Refraction. Bending of a ray of light travelling obliquely from one medium to another: the ray is refracted at the surface of the two media. The angle through which a ray will be bent can be calculated from the refractive indices of the media.

Rehalogenization. The process of converting deposits of black metallic silver back into silver halides. This process may be used to bleach prints in preparation for toning. (See TONER.)

Resin-coated (RC) paper. Photographic printing paper coated with synthetic resin to prevent the paper base absorbing liquids during processing. Resin-coated papers can be washed and dried more quickly than untreated papers.

Resolving power. Ability of an optical system to distinguish between objects that are very close together; also used in photography to describe this ability in a film or paper emulsion.

Reticulation. Fine, irregular pattern appearing on the surface of an emulsion which has been subjected to a sudden and severe change in temperature or in the relative acidity/alkalinity of the processing solutions.

Retina. Light-sensitive layer at the back of the eye.

Reversal film. Photographic film which, when processed, gives a positive image; that is, intended for producing slides rather than negatives.

Reversing ring. Camera accessory which enables the lens to be attached back to front. Used in close-up photography to achieve higher image quality and greater magnification.

Ring flash. Type of electronic flash unit which fits around the lens to produce flat, shadowless lightling; particularly useful in close-up work. Rising front. One of the principal CAMERA MOVEMENTS. The lens is moved vertically in a plane parallel to the film. Particularly important in architectural photography, where a rising front enables the photographer to include the top of a tall building without distorting the vertical lines. See also CONVERDING VERTICALS.

Sabattier effect. Partial reversal of the tones of a photographic image resulting from a secondary exposure to light during development. Sometimes also known as solARIZATION or, more correctly, pseudo-solarization, it can be used to give special printing effects.

Safelight. Special darkroom lamp whose light is of a color (such as red or orange) that will not affect certain photographic materials. Not all materials can be handled under a safelight, and some require a particular type of safelight designed specifically for them.

Saturated color. Pure color free from any admixture of gray.

Selenium cell. One of the principal types of photoelectric cell used in light meters. A selenium cell produces a current when stimulated by light, proportional to the intensity of the light.

Shading. Alternative term for DODGING.

Shutter. Camera mechanism which controls the duration of the exposure. The two principal types of shutter are BETWEEN-THE-LENS SHUTTERS and FOCAL-PLANE SHUTTERS.

Silver halide. Chemical compound of silver with a HALOGEN (for example, silver iodide, silver bromide or silver chloride). Silver bromide is the principal lightsensitive constituent of modern photographic emulsion, though other silver halides are also used.

Single-lens reflex (SLR) camera. One of the most popular types of camera design. Its name derives from its viewfinder system, which enables the user to see the image produced by the same lens that is used for taking the photograph. A hinged mirror reflects this image on to a viewing screen, where the picture may be composed and focused; when the shutter is released, the mirror flips out of the light path while the film is being exposed.

Slave unit. Photoelectric device used to trigger electronic flash units in studio work. The slave unit detects light from a primary flashgun linked directly to the camera, and fires the secondary flash unit to which it is connected.

Glossary

SLR. Abbreviation of SINGLE-LENS REFLEX CAMERA.

Snoot. Conical lamp attachment used to control the beam of a studio light.

Soft focus. Slight diffusion of the image achieved by the use of a special filter or similar means, giving softening of the definition. Soft-focus effects are generally used to give a gentle, romantic haze to a photograph.

Solarization. Strictly, the complete or partial reversal of the tones of an image as a result of extreme overexposure.

Spectrum. The multicolored band obtained when light is split up into its component WAVELENGTHS, as when a prism is used to split white light into colored rays; the term may also refer to the complete range of electromagnetic radiation, extending from the shortest to the longest wavelengths and including visible light.

Speed. The sensitivity of an emulsion as measured on one of the various scales (see ASA and DIN); or the maximum aperture of which a given lens is capable.

Spherical aberration. Lens defect resulting in an unsharp image, caused by light rays passing through the outer edges of a lens being more strongly refracted than those passing through the central parts; not all rays, therefore, are brought to exactly the same focus.

Spot meter. Special type of light meter which takes a reading from a very narrow angle of view; in some TTL METERS the reading may be taken from only a small central portion of the image in the viewfinder.

Spotting. Retouching a print or negative to remove spots and blemishes.

Standard lens. Lens of focal length approximately equal to the diagonal of the negative format for which it is intended. In the case of 35 mm cameras the standard lens usually has a focal length in the range of 50-55 mm, slightly greater than the actual diagonal of a full-frame negative (about 43 mm).

Stop. Alternative name for aperture setting or F-NUMBER.

Stop bath. Weak acidic solution used in processing as an intermediate bath between the DEVELOPER and the FIXER. The stop bath serves to halt the development completely, and at the same time to neutralize the alkaline developer, thereby preventing it lowering the acidity of the fixer when it is added.

Stopping down. Colloquial term for reducing the aperture of the lens. See also STOP.

Subminiature camera. Camera using 16 mm film to take negatives measuring 12 x 17 mm.

Subtractive color printing. Principal method of filtration used in making prints from color negatives. The color balance of the print is established by exposing the paper through a suitable combination of yellow, magenta or cyan filters, which selectively block the part of the light giving rise to an unwanted color CAST. See also ADDITIVE COLOR PRINTING.

Supplementary lens. Simple POSITIVE LENS used as an accessory for close-ups. The supplementary lens fits over the normal lens, producing a slightly magnified image.

Telephoto lens. Strictly, a special type of LONG-FOCUS LENS, having an optical construction which consists of two lens groups; the front group acts as a converging system, while the rear group diverges the light rays. This construction results in the lens being physically shorter than its effective focal length.

Test strip. Print showing the effects of several trial exposure times, made in order to establish the correct exposure.

TLR. Abbreviation of TWIN-LENS REFLEX CAMERA.

Tone separation. Technique similar to POSTERIZATION, used to strengthen the tonal range registered in a print by printing the highlights and the shadows separately.

Tone Refers to the range of grays between black and white.

Toner. Chemical used to alter the color of a black and white print. There are four principal types of toner, each requiring a different process for treating the print. Almost any color can be achieved through the use of toners.

Transparency. A photograph viewed by transmitted, rather than reflected, light. When mounted in a rigid frame, the transparency is called a slide.

T setting. Abbreviation of "time" setting—a mark on some shutter controls. The T setting is used for long exposures when the photographer wishes to leave the camera with its shutter open. The first time the shutter release is pressed, the shutter opens; it remains open until the release is pressed a second time. See also B SETING.

TTL meter. Through-the-lens meter. Built-in exposure meter which measures the intensity of light in the image produced by the main camera lens. Principally found in more sophisticated designs of SINGLE LENS REFLEX CAMERAS.

Twin-lens reflex (TLR) camera. Type of camera whose viewing system employs a secondary lens of focal length equal to that of the main ''taking'' lens: a fixed mirror reflects the image from the viewing lens up on to a ground-glass screen. Twin-lens reflex cameras suffer from PARALLAX error, particularly when focused at close distances, owing to the difference in position between the viewing lens and the taking lens. See also SINGLE-LENS REFLEX CAMERA.

Ultraviolet radiation. Electromagnetic radiation of wavelengths shorter than those of violet light, the shortest visible wavelength. They affect most photographic emulsions to some extent. See also INFRA-RED RADIATION.

UV filter. Filter used over the camera lens to absorb ULTRAVIOLET RADIATION, which is particularly prevalent on hazy days. A UV filter enables the photographer to penetrate the haze to some extent. UV filters, having no effect on the exposure, are sometimes kept permanently in position over the lens to protect it from damage.

View camera. Large-format studio camera whose viewing system consists of a ground-glass screen at the back of the camera on which the picture is composed and focused before the film is inserted. The front and back of the camera are attached by a flexible bellows unit, which allows a full range of CAMERA MOVEMENTS.

Viewfinder. Window or frame on a camera, showing the scene that will appear in the picture, and often incorporating a RANGEFINDER mechanism.

Vignette. Picture printed in such a way that the image fades gradually into the border area.

Virtual image. In optics, an image that cannot be obtained on a screen: a virtual image is seen in a position through which rays of light appear to have passed, but in fact have not. See also REAL IMAGE.

Wavelength. The distance between successive points of equal "phase" on a wave; the distance, for example, between successive crests or successive troughs. The wavelength of a wave is inversely proportional to its frequency. The wavelength of visible light determines its color.

Wetting agent. Chemical that has the effect of lowering the surface tension of water, often used in developers to prevent the formation of AIR BELLS, and in the final rinse (of film, in particular) to promote even drying.

Wide-angle lens. Lens of focal length shorter than that of a STANDARD LENS, and consequently having a wider ANGLE OF VIEW.

Working solution. Processing solution diluted to the strength at which it is intended to be used. Most chemicals are stored in a concentrated form, both to save space and to inhibit the deterioration of the chemical as a result of OXIDATION.

X-rays. Electromagnetic radiation with WAVELENGTHS very much shorter than those of visible light. X-rays are often used in the security checks at airports and can, if sufficiently powerful, fog film.

Zone focusing. Technique of presetting the aperture and focusing of the camera so that the entire zone in which the subject is likely to appear is covered by the DEPTH OF FIELD. This technique is particularly useful in areas of photography such as sports or action photography in which there is not enough time to focus the camera more accurately at the moment of taking the photograph.

Zone system. System of relating exposure readings to tonal values in picture-taking, development and printing, popularized by the photographer Ansel Adams.

Zoom lens. Lens of variable FOCAL LENGTH whose focusing remains unchanged while its focal length is being altered. Zooming is accomplished by changing the relative positions of some of the elements within the lens.

Index

Aerial photography, landscape 90 Angle of view choosing 42-3, 64-5 and focal length 13 portrait 73 Animals pets and zoo 96-7 wild 92 Aperture (f-stops) 11, 12, 136 Architecture 104-7 as background 46 converging verticals 134 focusing screen for 35 Artwork, photographing 22 ASA 120, 128 Backgrounds 46-7 and camera angle 86 landscape 90 nudes 79 portraits 70, 73, 74, 76-7 studio backdrops 24-5 Backlighting 56-7 meter reading for 19, 56-7 Barn door 20 Beach scenes 88-9 exposure for 38, 136 filters for 124 Bellows unit for lens 23 Blower brush, use of 26, 34, 112, 114 Burning-in 115, 136 burners 108 Cable release 22, 25 Camera types of 5-10 built-in meters 19 care of 34-5, 129 lens protection 124 storage 26 underwater 92 and flashgun 20 grips and harness for 22 holding 34-5, 36, 133 instant picture 5, 9 large-format reflex 5 loading 34-5 pin-hole 11 rangefinder 8 SLR 5, 6 TLR 5, 7 view 10 Children 80-1, 86 Chromatic aberration 32 Cinema screen, filming 100 Cleaning camera and lenses 26 contact printer 112 filters 16 negatives 114-15 Close-ups 85 composition 45 distortion, cause of 131 lens for 15 and TLR 7

Clouds filters for 17, 122, 125 Color temperature, Kelvin scale 127 Composition 42-3, 44-5, 48-9, 65 and backgrounds 46-7 and filters 58 Contrast filters for (b and w) 17, 125 high, exposure for 38-9 low, prevention of 120 reducing in enlarger 114 Converging verticals 134, 140 Copying photographs 22, 23 Cropping 22, 141 close-ups 45 Darkroom layout and equipment 108-9 Depth of field 12 and aperture 37, 134 and focus 37 Development b and w 30, 110-11 color 116-17 **DIN 120** Dodging 115 dodger 108 Double exposure 99, 101 Drying marks, removing 114, 141 Dunking 117 Dusk 88 for night shots 137 see also Evening and Sunset Emulsions, nature of b and w, 28-9 Enlargement b and w 28, 114-15 color 118 Enlarger lamp for contact printing Equipment cameras 5-10 darkroom 108-9 enlarger 114 lenses 23 lighting 20-1 processing b and w 110, 112, 123 color 117, 118-19 storage and presentation 26-7 studio 24-5 underwater 92 Evening 48 see also Dusk and Sunset Exposure 12 b and w 38 color 40-1 failure of 133-4 faulty 131, 133 with flash 131 and filters 124 guide to daylight 136 guide to night 137 reciprocity factor 137, 146 under- and over-, deliberate 41 Exposure meters 38, 142 built-in 6, 19

use of 18-19 for slide film 136 spot 18-19 Faces 70-7 Film b and w, types of 28-9, 120 color action of 30-1 types and brands 32-3, 120-2 use of varying types 60-1 instant 120 Filter factor 125 Filters 125 b and w 16, 125 color 58-9, 124, 125 conversion or correction 124 for flashguns 21 care of 16 polarizing 59, 124 special effects 126 Finder see Viewfinder Flare 57, 135 Flash with available light 62 bounced 102, 130, 131, 139 color temperature of 127 with daylight film 60 errors in use of 130-1 filters for 124 indoor use of 102 stroboscopic 100 umbrella 20, 25 for underwater 92 units in studio 25 Flashgun, electronic 20 guide numbers 127-8, 136-7, 143 slave units for 25 Floodlights, exposure for 137 Fluorescent light filters for 124 and types of film 60 Focal length 12-13 Focus and depth of field 37 errors 134 incorrect 133 Focusing 35 built-in 8 magnifier 23 screens 35 Foreground, eliminating 96, 107 Form 48-9, 67 Framing, incorrect 132 and see Aperture Garden 91 Glass 66 buildings 106 Glare, polarizing filter against 124

Grain in film 29 reducing in enlarger 114 Groups, portraits 82-4

Haze, filter for 16

Infra-red 59 Instant picture camera 5, 9 film types and brands 121 Interiors 102-3 exposure for 38, 137 film for 60 filters for 124 large, camera and lens for 103 lighting equipment for 20 see also Still life Kelvin scale 127 Landscape 44, 90 filters for 17 lenses for 14 meter reading for 18, 19 Lenses 11-15, 23 achromatic doublet 32 cleaning 26 coating of 135 chromatic aberration 32 errors in use of 132 long 86 pistol and rifle grip for 22 macro 91 for birds 95 for projectors 26-7 protection of 124 shift 23 for architecture 106 soft-focus 36 storage 26 telephoto-converter 15 underexposure with 135 telephoto 11 Light 60-3 bounced 21, 66 flash 102, 130, 131 color temperature 127 flood 137 fluorescent 60, 80, 124 tungsten 20 see also Backlighting, Flash Lighting equipment 20-1 Loading camera 133 Magnifying glass 26-7 for focusing 23, 108 Meters see Exposure meters Midday light *see* Sunlight Monopod 22 Moonlight 137 Morning, early 52, 54

Negatives cleaning 115 color, action of 30-1 emulsions 28 scratched avoiding 34 storage 27, 110 *see also* Development *and* Film Night, exposure guide for 137 Nudes 78-9

Multiple images 99

Index

Overexposure see Exposure Paper for printing b and w 114 color 119 Parallax error 7-8 Pattern 48-9 Perspective aerial 90 and composition 44 converging verticals 134 and landscape 90 three-dimensional effect 46, 66 Pets 96-7 Photofloods filters for 124 Pistol grip 22 Polaroid film and camera 9 Portraits interior 70-1, 74-5 exterior 72-3 character 76-7 groups 82-3 in available light 62 lens for 15 meter readings for 19 reflectors for 20 Printing b and w contact 112-13 enlarger 114-15 color 118-19 Processing see Development and Printing Projection, front 98 Projectors, slide 26-7 Rain, filming in 44, 54-5 after 89 Records, photographing for 50-1 **Reflections 64** Reflectors bulbs for 20 deep bowl 20 shallow bowl 25 Reversal film see Slides Rifle grip 22 Ring flash units 21 Roll film 28 Scratched film 129 Screen projector, glass beaded 27, 98 Seaside 88-9 filters for 124 Shane 48-9 Silhouette and composition 45 Skv filters for 16, 17, 124, 125 Shutter, camera focal plane (SLR) 6 leaf 7, 8, 10 Slides copying 23 developing 110, 116 exposure for 136 prints from 118-19 storage 26

types and brands of film 122 Snoot 20, 25 Sports 83 night photography 137 water 89 Still life 66-7 food 68-9 studio for 24-5 Storage 26-7 camera and film 27 containers and refrigerator 25 negatives 110 processing chemicals 119 Stroboscopic lights 100 Studio for children 80 layout 24-5 technique 98-101 Subjects, selecting 42-3 Sun, shooting into (backlight) meter reading 19, 56-7 portrait 73 Sunlight midday 52, 54-5, 87 for portraits 77 see also Morning, early and Evening Sunset 53, 56, 88 see also Evening Television screen, filming 100 Test strips for enlarger 114 Texture 48-9 and film types 29 filters for 16, 124 skin tones 43 Theatre stage, filming 137 Time of day 52-3, 65 and composition 44 see also Morning, early, Dusk, Sunlight and Evening Tongs, print 109, 113 Torch light 63 Transparencies see Slides Travel 84-5 Tripods 10, 22, 133 Tungsten light 20, 60 Underexposure see Exposure Underwater 92 Vacations 86-7 Viewfinders in cameras 6-10 right angle 23 use of 131, 132, 133 Vignettes by burning in 115 Water 93 filters for 124 Weather 54-5 Winter, exposures for 38-9 700 96-7

Keeping notes

Whether you keep a record of the exposures you make and how much detail you include is largely a matter of personal choice. Some photographers, notably those who use automatic cameras, keep no records at all. Other people methodically note down every detail of exposure, filtration and processing for each picture they take. I find that such a painstaking approach is too time-consuming, particularly when I am working in a hurry. However, it is always advisable to keep some reference notes for the following reasons:

- After a year or so has elapsed, you can very easily forget the name of the castle, the village or the river where you took a particular picture. For this reason, it is always useful to make brief caption notes and to annotate them with the roll number and negative numbers so that you can match them up at a later date.
- 2. When you are trying out new techniques or special effects, you will find that the aperture or shutter speed used assumes greater importance than usual. Keeping a record will help you to reproduce an effect that you liked: memory alone is rarely sufficiently reliable.
- 3. If your equipment malfunctions, you will have difficulty tracing the fault unless you have recorded which lens or camera body was in use at the time.
- 4. If you send your film away for processing and the laboratory loses it, of you forget to enclose your name and address, the chances of recovering your pictures are much greater if you can tell the processor what the subjects were and, more important, in what order the subjects appear on the film.
- 5. Record-keeping helps you to control the quality of your pictures. Color processing laboratories are not all identical, and one place may develop color transparency film to a consistently higher density than another. This is why there is a box on the forms for you to note down where the film was processed. If you process your own film then record-keeping is especially important. By monitoring the time and temperature of the development process, you can build up a valuable log that will help you decide how to process future films, particularly when you know you have under- or overexposed.

Agfa	Film Type Agfacolor 100 ASA		ocessing notes ing Photo Lab lood results d fast	Printing notes Subjects in shade, slight cyan cast
Date	Frames	Camera/ Lens	Location/Subject	Exposure/Notes
8.1083	1 2 3	Olympus OM2 Somm	View from boat trip alongseine	1/125, f5.6
	4	U l	Notre Dame- exterior views	1/250, F5.6
(1	7 8	200mm	Gargoyles, west side	1/30, F8
4	9	50mm	Notre Dame- at 10-250m	Tripod Vaser F5.6

Film	1 Туре	Pro	ocessing notes	Printing notes
Date	Frames	Camera/ Lens	Location/Subject	Exposure/Notes
	1			
	2			
	4			
	5 6			
	7			
	8			
	10	.		
	11 12			
	13			
	14 15			
	16			
	17 18			
	19			
	20 21			
	22			
	23			
	24 25			
	26			
	27 28			
	29			
	30 31			
	32			
•	33 34			
	35			
	36			

Film	Film Type		ocessing notes	Printing notes
Date	Frames	Camera/ Lens	Location/Subject	Exposure/Notes
Date	1 2 3 4 5 6 7 8 9 10 11 12 13 14 15 16 17 18 19 20 21 22 23 24 25 26 27 28	Lens	Location/Subject	Exposure/Notes
	29 30 31 32 33 34 35 36			

Film Type		Processing notes		Printing notes
Date	Frames	Camera/ Lens	Location/Subject	Exposure/Notes
	1 2 3 4 5 6 7 8 9 10 11 2 13 14 15 16 7 8 9 10 11 2 3 4 5 6 7 8 9 10 11 2 3 4 5 6 7 8 9 10 11 2 3 4 5 6 7 8 9 10 11 2 3 4 5 6 7 8 9 10 11 2 3 4 5 6 7 8 9 10 11 2 3 4 5 6 7 8 9 10 11 2 3 4 5 6 7 8 9 10 11 2 3 4 5 6 7 8 9 10 11 2 3 4 5 6 7 8 9 10 11 2 3 4 5 6 7 8 9 10 11 2 3 4 5 6 7 8 9 10 11 2 3 4 5 6 7 8 9 10 11 2 3 4 5 6 7 8 9 10 11 2 3 4 5 6 7 8 9 10 11 2 3 4 5 6 7 8 9 10 11 2 3 4 5 6 7 8 9 10 11 2 2 3 4 5 6 7 8 9 10 11 2 2 3 4 5 6 7 8 9 10 11 2 3 4 5 6 7 8 9 10 11 2 2 2 3 2 4 5 6 7 8 9 0 31 2 2 3 2 4 5 6 7 8 9 31 3 2 3 3 3 3 3 3 3 3 3 3 3 3 3 3 3 3			

Film Type		Processing notes		Printing notes
Date	Frames	Camera/ Lens	Location/Subject	Exposure/Notes
	1 2 3 4 5 6 7 8 9 10 11 12 13 14 15 16 17 18 19 20 21 22 23 24 25 26 27 28 29 30 31 32 33 34 35 36			

Film Type	Pr	ocessing notes	Printing notes	
Date Fran	nes Camera/ Lens	Location/Subject	Exposure/Notes	
1 22 33 4 5 6 6 7 7 8 9 9 10 11 12 13 14 15 16 17 18 19 20 21 22 23 24 25 26 27 28 29 30 31 32 33 34 35 36				

Date Frames Camera/ Lens Location/Subject Exposure/Notes 1 2 3 4 5 6 3 4 5 6 7 7 8 9 9 10 11 12 10 11 12 13 14 15 16 17 18 9 9 10 10 11 12 13 14 15 16 17 18 9 10 11 12 13 14 15 16 17 18 19 20 21 22 23 24 25 26 26 27 28 29 30 31 32 33 4	Film Type		Processing notes		Printing notes
Date Frames Lens Location output Exposition researce 1 2 3 4 5 6 7 8 9 10 11 12 13 14 15 16 17 18 19 20 21 22 23 24 25 26 27 28 29 30 31 32					
2 3 4 5 6 7 8 9 10 11 12 13 14 15 16 17 18 19 20 21 22 23 24 25 26 27 28 29 30 31 32	Date	Frames	Lens	Location/Subject	Exposure/Notes
34 35 36		2 3 4 5 6 7 8 9 10 11 12 13 14 15 16 17 18 19 20 21 22 23 24 25 26 27 28 29 30 31 32 33 34 35			

Film	Film Type		ocessing notes	Printing notes	
Date	Frames	Camera/ Lens	Location/Subject	Exposure/Notes	
	1 2 3 4 5 6 7 8 9 10 11 12 13 14 15 16 17 18 9 20 21 22 23 24 25 26 27 28 29 30 31 32 33 4 35 36				

Film Type		Processing notes		Printing notes
Date	Frames	Camera/ Lens	Location/Subject	Exposure/Notes
	1 2 3 4 5 6 7 8 9 10 11 12 13 14 15 16 17 18 19 20 21 22 23 24 25 26 27 28 29 30 31 32 33 34 35 36 36 36 37 36 37 37 37 37 37 37 37 37 37 37			

Film Type	Pri	ocessing notes	Printing notes
Date Frame	Camera/ Lens	Location/Subject	Exposure/Notes
1 2 3 4 5 6 7 8 9 10 11 12 13 14 15 16 17 18 19 20 21 22 23 24 25 26 27 28 29 30 31 32 33 34 35 36			

Film	Film Type		ocessing notes	Printing notes
Date	Frames	Camera/ Lens	Location/Subject	Exposure/Notes
	1 2 3 4 5 6 7 8 9 10 11 12 13 14 15 16 17 18 9 20 21 22 23 24 25 26 27 28 9 30 31 32 33 4 35 36			

Film Type		Pro	ocessing notes	Printing notes
Date	Frames	Camera/ Lens	Location/Subject	Exposure/Notes
	1 2 3 4 5 6 7 8 9 10 11 12 13 14 15 16 17 18 19 20 21 22 23 24 25 26 27 28 29 30 31 32 33 34 35 36 35 36 35 36 35 36 35 36 35 36 35 36 36 36 37 37 37 37 37 37 37 37 37 37			

Film Type	Pr	ocessing notes	Printing notes
Date Frames	Camera/ Lens	Location/Subject	Exposure/Notes
1 2 3 4 5 6 7 8 9 10 11 12 13 14 15 16 17 18 19 20 21 22 23 24 25 26 27 28 29 30 31 32 33 34 35 36			

Film Type		Pro	ocessing notes	Printing r	iotes
		Camera/	Lauretine (Subject	Exposure/	Notes
Date F	rames	Lens	Location/Subject	Exposure/	Notes
	1 2 3 4 5 6 7 8 9 10 11 12 13 14 15 16 17 18 19 20 21 22 23 24 25 27 28 29 30 31 23 34 35 36 31 32 33 34 35 36 36 37 37 37 37 37 37 37 37 37 37	Leris			

Film	Film Type		ocessing notes	Printing notes
Date	Frames	Camera/ Lens	Location/Subject	Exposure/Notes
	1			
	2			
	3 4			
	5			
	6			
	7			
	8			
	9 10			
	10			
	12			
	13			
	14			
	15			
	16 17			
	18			
	19			
	20			
	21			
· · · · ·	22 23	· · · ·		
	23			
	25			
	26			
	27			
	28			
	29 30			
	30			
	32			
	33			
	34			
	35			
	36			

Film Type		Processing notes		Printing notes
Date	Frames	Camera/ Lens	Location/Subject	Exposure/Notes
	1 2 3 4 5 6 7 8 9 10 11 12 13 14 15 16 17 18 19 20 21 22 23 24 25 26 27 28 29 30 31 32 33 34 35 36			

Film	Film Type		ocessing notes	Printing notes
Date	Frames	Camera/ Lens	Location/Subject	Exposure/Notes
	1 2 3 4 5 6 7 8 9 10 11 12 13 14	Letis		
	15 16 17 18 19 20 21 22 23 24			
	25 26 27 28 29 30 31 32 33 34			
	35 36			

Film	Film Type		ocessing notes	Printing notes
Date	Frames	Camera/ Lens	Location/Subject	Exposure/Notes
	1 2 3 4 5 6 7 8 9 10 11 12 13 14 15 16 17 18 9 20 21 22 32 4 25 26 27 8 9 30 31 23 34 35 36			

Film	Film Type		ocessing notes	Printing notes
Date	Frames	Camera/ Lens	Location/Subject	Exposure/Notes
	1 2 3 4 5 6 7 8 9 10 11 12 13 14 15 16 17 18 9 20 21 22 23 24 25 26 27 28 29 30 31 32 33 4 35 36			

Film	Film Type		Processing notes Printin	
Date	Frames	Camera/ Lens	Location/Subject	Exposure/Notes
	1 2 3 4 5 6 7 8 9 10 11 12 13 14 15 16 17 18 19 20 21 22 23 24 25 26 27 28 29 30 31 32 33 34 35 36			

Film Type		Pro	Processing notes Printing	
Date F	rames	Camera/ Lens	Location/Subject	Exposure/Notes
	1 2 3 4 5 6 7 8 9 10 11 12 13 14 15 6 17 8 9 10 11 12 13 14 15 6 17 8 9 10 11 12 13 14 15 6 17 8 19 20 12 22 24 25 26 27 28 29 30 13 23 34 35 36 36 36 36 36 36 36 36 36 36 36 36 36			

Film Type		Pro	ocessing notes	Printing notes
Date	Frames	Camera/ Lens	Location/Subject	Exposure/Notes
	1 2 3 4 5 6 7 8 9 10 11 12 13 14 15 16 17 18 19 20 21 22 23 24 25 26 27 28 9 30 31 32 33 4 35			

Film	Film Type		ocessing notes	Printing notes
Date	Frames	Camera/ Lens	Location/Subject	Exposure/Notes
	1 2 3 4 5 6 7 8 9 10 11 2 3 4 5 6 7 8 9 10 11 2 3 14 15 16 17 8 9 20 21 22 23 24 5 26 27 28 9 30 31 22 33 4 5 6 7 8 9 10 11 23 4 5 6 7 8 9 10 11 23 4 5 6 7 8 9 10 11 23 4 5 6 7 8 9 10 11 23 4 5 6 7 8 9 10 11 23 4 5 6 7 8 9 10 11 23 4 5 6 7 8 9 10 11 23 4 5 6 7 8 9 10 11 23 4 5 6 7 8 9 10 11 23 24 5 5 6 7 8 9 10 11 22 22 23 24 5 5 6 7 8 9 10 11 22 22 23 24 5 5 6 7 8 9 10 11 22 22 23 24 5 5 6 7 8 9 10 11 22 23 24 5 26 7 28 9 30 31 22 23 24 5 26 7 28 9 30 31 22 23 24 5 26 7 27 20 31 22 23 24 5 26 27 27 28 29 30 31 32 33 33 33 33 35 35 36 35 36 31 32 33 34 35 35 35 35 35 35 35 35 35 35 30 31 32 33 33 35 35 35 35 35 35 35 35 35 35 35			